AMERICAN FRONTIERS

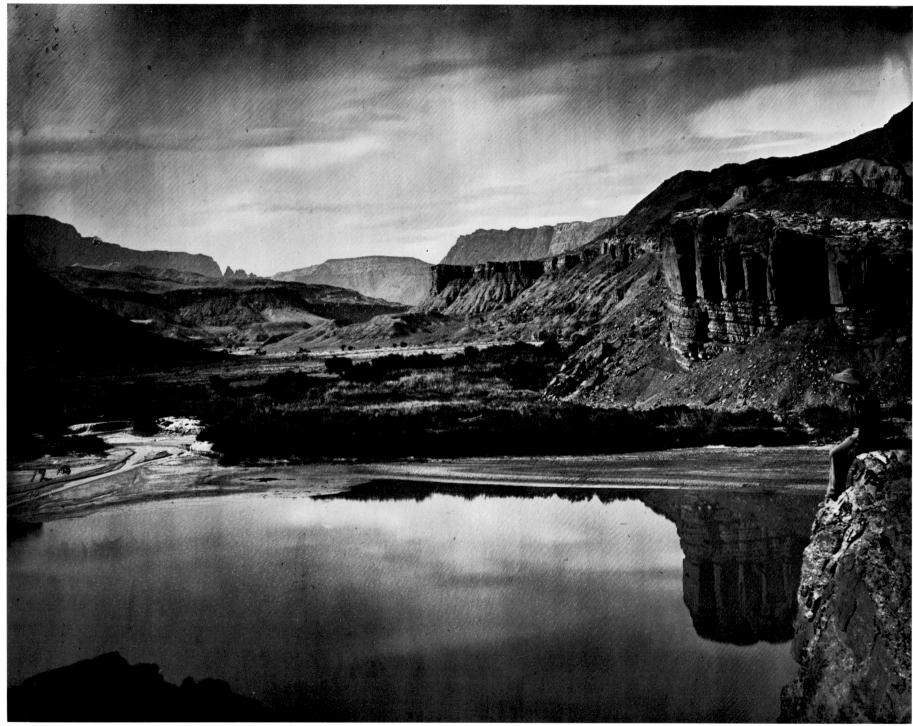

Looking across the Colorado River to mouth of Paria Creek, Arizona, 1873

AMERICAN FRONTIERS

The Photographs of Timothy H. O'Sullivan, 1867-1874

JOEL SNYDER

APERTURE

FOR JEAN

Special research for this book was provided by Jonathan Heller, Still Pictures Branch, The National Archives, Washington, D.C.

Staff for *American Frontiers: Photographs of Timothy H. O'Sullivan, 1867–1874:* Editor/Publisher, Michael E. Hoffman; Associate Editor, Carole Kismaric; Managing Editor, Lauren Shakely; Production Manager, Stevan A. Baron; Designer, Wendy Byrne.

Aperture, Inc., publishes a periodical, portfolios, and books to communicate with serious photographers and creative people everywhere. A complete catalogue will be mailed upon request. Address: Millerton, New York 12546.

Manufactured in the United States of America. Composition by National Photocomposition Services, Syosset, New York. Printed by Meriden Gravure Company, Meriden, Connecticut. Bound by Publishers Book Bindery, Long Island City, New York.

American Frontiers: Photographs of Timothy H. O'Sullivan 1867–1874 is an exhibition presented by the Alfred Stieglitz Center at the Philadelphia Museum of Art from October 3, 1981, to January 3, 1982. The exhibition was directed by Joel Snyder and Michael E. Hoffman, and coordinated and designed by Martha Chahroudi. Thereafter the exhibition will travel in the United States and Canada. The exhibition and this publication are supported by a grant from the National Endowment for the Arts, Washington, D.C., a federal agency.

CONTENTS

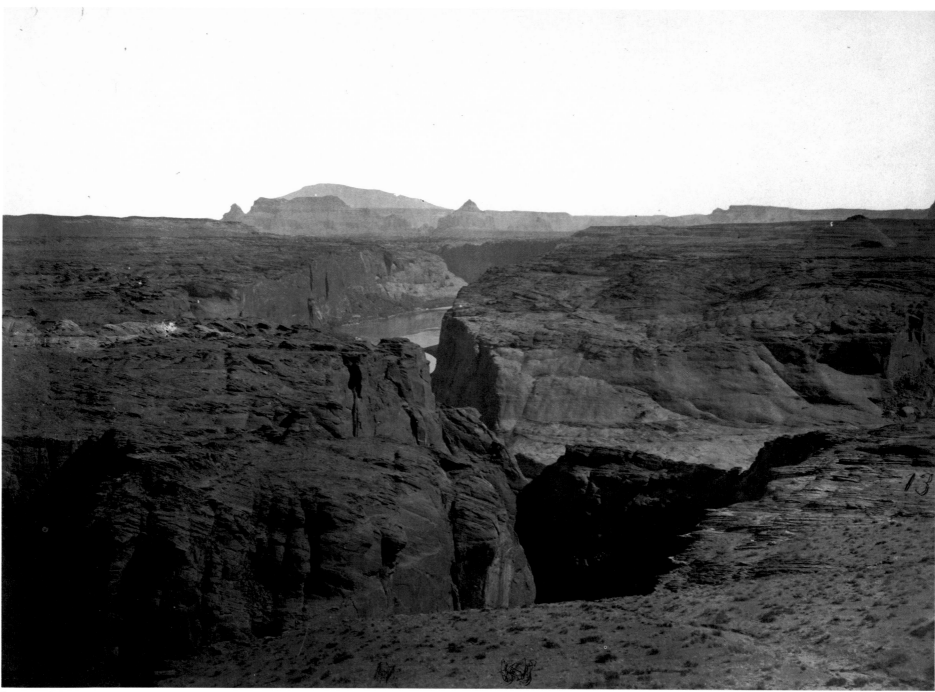

Canyon of the Colorado River, Arizona, 1873

INTRODUCTION

TIMOTHY H. O'SULLIVAN crossed the frontier in the spring of 1867, as photographer for the first modern survey of the American West. He left it for the last time in 1874. In those seven years he produced over one thousand photographs of an immense, unknown region of the American wilderness. The scientific results of the surveys on which he served were widely disseminated and carefully studied, but O'Sullivan remained unnoted and unappreciated for nearly three quarters of a century after his death. Some of O'Sullivan's contemporaries — Carleton Watkins, William Henry Jackson, and Eadweard Muybridge — became renowned for their landscapes of the West. For them, the American interior was essentially picturesque, the raw material for pictures that demonstrated the glories of nature and confirmed a belief in its inherent hospitality. In contrast, O'Sullivan's vision of the interior is an awed stare into a landscape that is yet unmarked, unmeasured, and wild — a place in which man is not yet the measure of all things. O'Sullivan's interior is a boundless place of isolation, of contrasts of blinding light and impenetrable shadow. It is astonishing, often alienating, rarely benign.

The interior is ultimately mysterious, but not in a religious sense in which mystery offers comfort by infusing faith. It is the mystery of the unknown and the terrifying.

At the close of the Civil War, the American interior ran a little under fifteen hundred miles from the Missouri River at Saint Joseph, Missouri, to the eastern slopes of the Sierra Nevada Mountains in California and about fourteen hundred miles from the Mexican border in the southwest to the Canadian border in the north. This vast territory of more than two million square miles was dotted here and there with makeshift frontier towns, settlements, and camps. At the very heart of the interior was the Great Basin, the last remnant of "The Great American Desert," which stretched from the Rocky Mountains to the Sierra Nevadas and covered the eastern edge of California, all of present day Nevada, Utah, Arizona, New Mexico, and parts of Colorado and Wyoming.

The western frontier is often pictured as a continuous thread of highways joining towns that fringed the interior, as if a line drawn between dots on a map could constitute a genuine dividing line between what passes for civilization

and what is known to be wilderness. The interior slowly gave way to the frontier, but with no coherent planner's map in mind. Perhaps Mark Twain best expressed the vague boundary between interior and frontier when he wrote in *Roughing It* of getting lost and nearly dying in a snowstorm near Carson City, Nevada: "We seemed to be in a road, but that was no proof." The frontier underwent constant redefinition and relocation — slowly moved by fur trappers, miners, ranchers, farmers, and the merchants who came to serve them, and finally by the builders of the great transcontinental railroads. Camps and towns were built, often overnight, by men who came west desperate for wealth and who mostly had to settle for meager wages — men willing to work without rest; to work even harder than in the eastern factories they sought to escape; and to work and live under lawless, even savage conditions, with few, if any guarantees about the future. Settlement depended upon the unknown and therefore unpredictable resources of the land — gold and silver, water, and rich farming or grazing lands — and camps often fell as fast as they went up. Each settlement was experimental, a test based on a lucky find or a hunch.

By the mid-1860s, it was clear that if the interior was to be civilized, it would have to be managed systematically, and this, in turn, would require a thorough description — an inventory — of its resources, natural history, topography, and native population. The explorations of the West that began in 1867 were not the first organized by the Federal government: explorations had begun more than a half century before with Lewis and Clark's expedition to the Pacific Coast in 1804 and 1805. But, until after the Civil War, surveys had always been led by soldiers. Although the soldier-surveyors possessed, in addition to the skills of surviving in the wilderness, some expertise in map making and in various departments of natural science, they were not trained as scientists. After the Civil War, the western surveys, to the great resentment of the military men, were conducted by professional scientists who were schooled in the established European methods of scientific observation and description. The artists who went west as part of the survey teams, whether painters or draftsmen or photographers, had absorbed the European landscape tradition of picture making. For the most part, they depicted nature in accordance with that tradition — as picturesque, perhaps majestic, but always somehow inviting.

The experience in the interior brought changes to the European mode of landscape depiction. Nowhere is that

transformation more apparent or stunning than in the work of Timothy H. O'Sullivan. In his photographs, traditional conceptions of what is worth depicting and the means of observing and describing it in pictorial terms — in short, the notion of subject matter — are challenged and transformed.

O'Sullivan's character as a picture maker is revealed through his photographs, but little is known of his personality or even of those impersonal bits of factual information that locate a person in a community. What is known is slim, suggestive and ultimately mysterious itself. By his own words, written in his own hand, he was born in Staten Island, New York, in 1840.[1] Yet, according to his death certificate, filled out by his physician (most certainly with information provided by his father, Jeremiah), O'Sullivan was born in Ireland in 1840.[2] The baptismal records in Saint Peter's, the O'Sullivan family church on Staten Island, show many entries for the year 1840, but none for Timothy O'Sullivan. In a number of papers and letters, including his death certificate, a letter from his closest friend to the geologist Clarence King,[3] and a notation on the back of a portrait by Alexander Gardner of O'Sullivan that he presented to his future wife in December 1868, O'Sullivan is referred to as "Sullivan." Nevertheless, since no Timothy Sullivan or O'Sullivan appears in the baptismal records of the family church, and since the Federal Census records for 1840 do not show an entry for a family headed by Jeremiah and Ann, O'Sullivan's parents, on Staten Island, O'Sullivan was probably born in Ireland. The family no doubt moved to the United States sometime during the great wave of Irish immigration brought on by the potato famine that began in the 1840s. The records in Saint Peter's Church do show an entry for Tim Sullivan as having been confirmed on 11 November 1855,[4] which would have been about the right time for O'Sullivan's confirmation. He is also referred to in the same way in the church burial records.

The details of O'Sullivan's early years are now beyond recall. The frequency with which he returned as an adult to his parents' home on Staten Island suggests that he enjoyed a close relationship with his family. The simple elegance of the existing letters in his hand indicate that he received a reasonably rigorous formal education, perhaps at the church school. At about the age of sixteen he was prepared to leave home and begin his apprenticeship in the young and difficult craft of photography. Before he returned to his family home for the last time in 1881 he would travel tens of thousands of miles through the unknown wilderness.

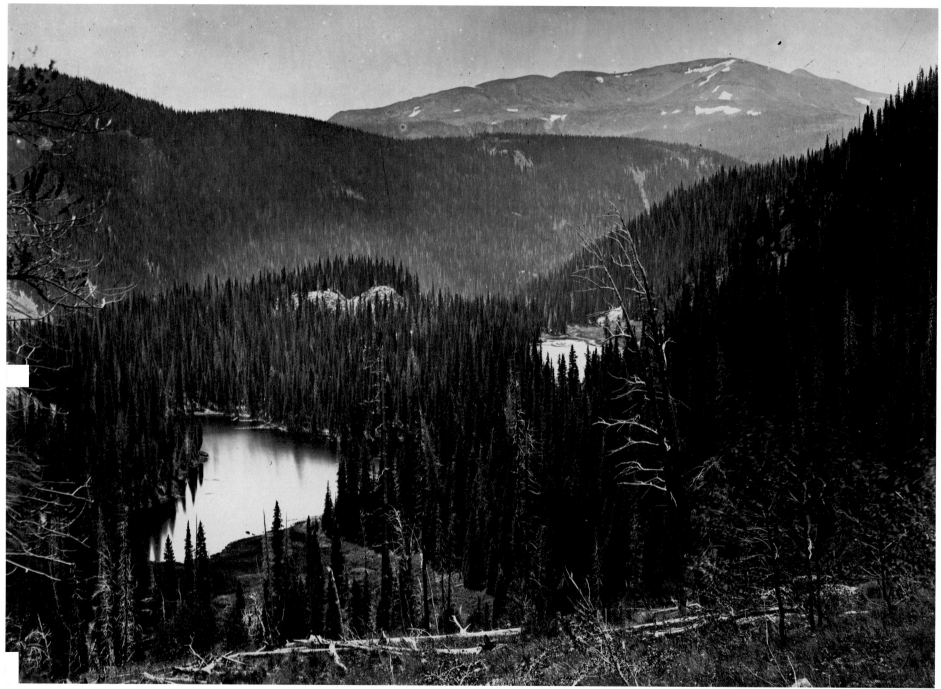

"Lost" lakes near Meigs Peak, Colorado, 1874

I.

IRONICALLY FOR A PHOTOGRAPHER whose professional life was conducted under rugged, often primitive, conditions, Timothy H. O'Sullivan began his training in plush surroundings — the nationally renowned studios of Mathew Brady. Designed as sumptuous parlors in which the rich and famous might be photographed with the least possible discomfort, Brady's studios provided his elite clientele with an ambiance of overstuffed elegance. Whether O'Sullivan started as an apprentice in Brady's New York studio, or whether he first found employment at his Washington, D.C., studio, he was already living in Washington by about 1856 or 1857. It was at that time that he first became acquainted with his lifelong friend and professional associate Lewis E. Walker, who had just taken a position as photographer at the Department of the Treasury.[5]

Learning the photographic trade in the late 1850s was exciting and vexing. The elegant daguerreotype process had given way to the wet-collodion process, which, though it offered the advantage of multiple prints, was anything but elegant. An apprentice had to learn not only the rudiments of exposure and printing, but how to make all the photosensitive materials by mixing raw chemicals. In the studio, apprentice operators (as photographers were then known) assisted in every aspect of making photographs. While the experienced and socially adept camera operator focused on the subject and kept him or her engaged in polite banter, the apprentice stepped into the orange-lit darkroom and poured the etherial collodion onto a plate of glass and plunged it into a silver nitrate solution. After about three minutes, the plate was withdrawn, slipped into a light-tight plate holder while still thoroughly wet and brought out to the camera operator, who had prepared the sitter for the exposure. Once the plate received its ten- or twenty-second exposure, the plate and plateholder were returned to the apprentice, who rushed them back to the darkroom and processed the plate before it dried. In addition to this furious racing about, the apprentice learned how to make collodion as well as the other necessary solutions and materials required at each step of the process.

O'Sullivan was working at Brady's Washington studio when Brady turned over the management of the operation to the Scottish photographer Alexander Gardner. Gardner was exceptionally accomplished with the wet-plate process and was masterful in the production of enlarged negatives from small plates. He was also a man of commanding presence and picture-making ability. And, as it turned out, he was a fine judge of photographic talent.

O'Sullivan was doubly fortunate in working for the Brady studio under Gardner's direction. A print that had the Brady stamp was expected to meet the highest technical and esthetic standards of the art. Moreover, Brady's accomplished and wealthy clientele included the most famous residents and visitors to the city. The Brady studio, by placing O'Sullivan in constant contact with an educated and genteel clientele and by giving an example of how a photographer engaged in dealings with such clients, functioned as his "finishing school" as well as his trade school.

Like most studios of the day, Brady's was a portrait studio, rarely accepting commissions out of doors, or "field" work. The process made such work difficult, to say the least. Asking a photographer to produce first-quality

photographs in the field would have been something like ordering a master chef to produce an elegant dinner in an army field kitchen. The primary requirement for field photography was a self-contained, portable darkroom, not yet an article of commerce in the late 1850s and early 1860s. When the Civil War erupted in April 1861, Federal troops sent to protect Washington and to prepare for an advance on the newly formed Confederacy encircled the city. In May 1861 Brady journeyed to Washington and visited the troop encampments to photograph them and their officers. He outfitted a portable darkroom in the form of a delivery wagon, and most probably used O'Sullivan as an assistant, since in June Gardner lent O'Sullivan to the visiting New York photographer J. F. Coonley as an experienced field assistant to aid in the production of field photographs around the city. On 21 July, Brady, accompanied by O'Sullivan and Alfred Waud, the illustrator for *Harper's Weekly*, traveled to Bull Run to photograph the makings of what was assumed to be a decisive Federal victory.

Though only twenty-one years old, O'Sullivan was more than just an assistant whose job it was to prepare and process the wet plates for Brady. Brady's eyesight was already failing, and O'Sullivan not only poured and later processed the plates, but operated the camera as well. Eight years later, O'Sullivan recalled that he might have photographed the battle itself and not just the preparations of war, "but for the fact that a shell from one of the rebel field pieces took away [his] camera."[6] The battle was a humiliating defeat for the Federal army, and the troops, along with Brady, O'Sullivan, Waud, and a whole contingent of civilian onlookers, literally galloped back to Washington.

In the autumn of 1861 Brady made plans to photograph the young war by dispatching fully equipped photographers into the field. His motivation for initiating this pioneer project of war documentation was complex. He was moved by patriotic feelings and by the romance of a glorious and righteous cause, but also by the knowledge that he could sell prints of war-related activities and portraits of the officer corps through his own studios and through the sales

Ruins of Fort Pulaski, Georgia, inside casement wall, fourteen feet thick, 1862

offices of E. & H. T. Anthony, the major supplier of photographic materials and supplies in America. He also thought that display of these pictures in his studios would enhance his already large portrait trade.

At about this time O'Sullivan began making photographs in South Carolina. He may have been sent there by Brady to photograph General W. T. Sherman's expedition, or,

moved by the patriotic feelings that were sweeping the country, may have enlisted and traveled to South Carolina with the army. Later in his life O'Sullivan wrote that he was attached, as a first lieutenant, to the staff of General Egbert Viele's Division, which was under Sherman's overall command, but army records do not confirm this claim.[7] However he accomplished it, O'Sullivan did manage to equip himself for photographic field work and spent the period between December 1861 and May 1862 photographing the military activities as well as spots of scenic interest at Beaufort, Port Royal Island, Bay Point, Seabrook Point, and Hilton Head, South Carolina, as well as Fort Pulaski, Georgia (pages 12, 15). O'Sullivan's prints from this period demonstrate that he had completely overcome the difficulties of managing the wet-plate process in the field. They are pictures of the destructive effects of war and, in odd contrast, picturesque views of the grand plantation homes on the islands off the Carolinas.

In May 1862 O'Sullivan returned to Washington to find that Gardner had left Brady to go into business on his own. O'Sullivan returned to work briefly for Brady, listing Brady's studio as his home address in the *Washington Directory*, but then went to work for Gardner. His new employer had accepted a job as a civilian photographer to the army at the same time that he was setting up his own studio in Washington. Gardner appointed O'Sullivan "Superintendent of the Field or Copy Work to the Army of the Potomac" and divided his own time between his new studio and the mobile army headquarters. O'Sullivan's main assignment was to copy maps, and he had to work quickly, because his copies were immediately distributed to field commanders for use in their preparations for troop movements or for battle. Despite what appears in the army records to have been a considerable amount of map copying and print production, O'Sullivan had enough free time to

Photographic van on the battlefield of Manassas, 4 July 1862

photograph the everyday operations of the army, the new technology that was being developed to facilitate the business of war, and the aftermath of battles. These negatives were then shipped to Washington, where they were printed and sold under the general title *Photographic Incidents of the War from the Gallery of Alexander Gardner, Photographer to the Army of the Potomac*. Gardner also printed and mounted views and stereo pairs that were sold by the Washington publisher Philp and Solomons, again under the title *Photographic Incidents of the War*. Additionally, the negatives were often duplicated in the darkroom and sold to other photographers, including Brady, to be used in their photographic publishing ventures. The prints for these ven-

tures were made one at a time on albumen paper.[8] By the end of the war, Gardner claimed to have over 3,000 negatives in his possession, and, while some of them had doubtlessly been purchased from other photographers, the vast majority were made by O'Sullivan, Gardner, and Gardner's brother, James.

O'Sullivan spent the rest of the war working for Gardner and the army. He was present at many of the major actions

Timothy H. O'Sullivan, c. 1868, by Alexander Gardner. E. Marshall Pywell Collection

of the war, including Antietam, Fredericksburg, Aquia Creek, Fairfax Court House, Gettysburg, Petersburg, and Appomattox. O'Sullivan's photographs, particularly those of the aftermath of battle, the dead at Antietam and Gettysburg, and the devastated cities of the South are among the most memorable of the war. But this is not to say that he

had developed a personal style. That would have been contrary to the purpose for which the photographs were made—to be sold. For the most part, Civil War photographs were designed to reassure the audience that there had been no narrative or authorial intervention on the part of the picture maker. There is an uncanny sameness to the look of most of the photographs. Nearly all were made straight-on, without any tilting of the camera. Nearly all were made at a respectable or even great distance from the subject. The depth of field—the range of apparent maximum sharpness—is great; all planes are rendered in sharp delineation. The photographs deemphasize the picture maker's function as a narrator who directs attention to particular aspects of a scene. The audience was willing to accept the attribution of a photograph to a particular photographer, but it was not prepared to think of war views as "subjective impressions" or as "personal interpretations." These views are supposed to belong to every man, to make the viewer believe, "This is what I would have seen if I had been there."

Yet there are three prints in Gardner's *Photographic Sketchbook of the War*[9] that implicate the photographer in the act of presentation, and each deals with death. O'Sullivan's *A Harvest of Death*[10] shows the immediate foreground out of focus, a slip of the fore- and middle ground—which contains the most prominent corpses in sharp focus—and the background distinctly out of focus. The weighting of the focus, so unusual in most photographs of the war, has a chilling effect on the viewer. It is as if the beholder had just come upon the scene and was so transfixed by the bloated and dreadful remains of the troops that lie before him that he could not take his attention from them and attend to

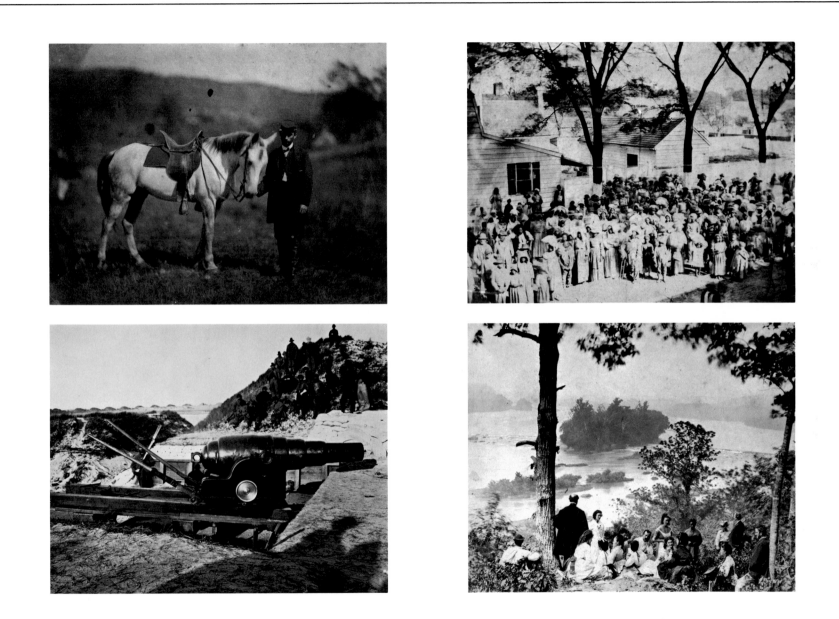

Above left, scout, c. 1863; *right*, slaves on J. J. Smith's plantation, Beaufort, South Carolina, 1862; *below left*, captured Confederate cannon, Fort Pulaski, Georgia, 1862; *right*, High Island, summer encampment of General Spinner, Treasurer of the United States, c. 1863

whatever else was in the field of view. The same selective use of focus characterizes the appalling vision of *Field Where General Reynolds Fell* (page 17).[11] The foreground and background are placed out of focus and the swelling corpses are the only things, and now, they are only *things*, in sharp focus. (Still, the picture and the title conspire to tell

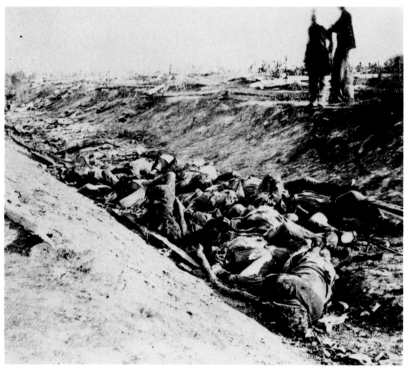

"The Sunken Road," Antietam battlefield, Confederate dead left at the point of attack by General Kimball's brigade, 1862

a modern viewer how much our notions have changed since 1863 of what constitutes the subject matter of war. This field is noteworthy, Gardner tells us, because it is the place where General Reynolds fell. But the General received a prompt burial in keeping with his rank — he is absent from the photograph. Who then were these corpses — these men who go unnamed in the caption? The answer in 1863, apparently, was that they were just the troops.)

Only one other picture in the book uses the same device of keeping the corpse in focus while softening the rest of the field. It is *A Sharpshooter's Last Sleep*,[12] attributed to Alexander Gardner. Perhaps significantly, this photograph is ascribed to "T. H. O. Sullivan" in Gardner's catalogue of 1863, as is the equally famous *Home of a Rebel Sharpshooter*,[13] which is also attributed to Gardner in the *Sketchbook*. It is difficult to imagine how Gardner might have originally misattributed these photographs to O'Sullivan, although it is possible that they were made jointly by the two photographers and that by the time the *Sketchbook* was published Gardner decided to take exclusive credit. Whatever the correct attribution, most Civil War photographers did not take such liberties with focus. This fact, coupled with the ease with which O'Sullivan might have achieved overall focus, implies strongly that the extraordinary effect was intended. Still, the use of these special effects does not mean that O'Sullivan had developed a style apart from those of the other war photographers, only that he could manipulate the camera to achieve desired effects.

O'Sullivan's war experience had equipped him for the difficulties of extended field work. He had proved that he could make photographs with the aid of an assistant, or on his own, under the conditions encountered by armies on the march, in the fields after great armies had engaged in mutual destruction, and in those long periods in which soldiers carry out the boring day-to-day routines of camp life. He had achieved a reputation among his fellow photographers as a thoroughly professional technician and "artist in the field" and as one of the foremost photographers of the

war. The Civil War was considered a holy one by many of his countrymen — including Alexander Gardner — and O'Sullivan walked upon and photographed many of the "sacred" fields of battle.[14] At the age of twenty-five, O'Sullivan had spent three years in the field with the army and had adjusted to the discomforts of army life in the midst of a great national catastrophe. It must have been difficult for him to readjust to the demands of a genteel portrait studio trade.

At the close of the war, O'Sullivan moved back to Washington. He continued to work for Gardner, probably assisting with the printing of the views for the *Sketchbook*. This work of printing thousands of views prepared him for the printing work that he would be assigned less than nine years later. In 1866 O'Sullivan was listed in the *Washington Directory* as a photographer living at 567 6th Street, West. In 1867 he was listed as "photo. op." boarding at Dyer's Hotel. The *Directory* does not list him again until 1876.

In January 1867 Clarence King, a twenty-five-year-old graduate of Yale's Sheffield Scientific School just recently returned from geological surveying in California under the direction of Professor Josiah D. Whitney, convinced Secretary of War Edwin M. Stanton to promote a War Department survey that would produce "a geological and topographical exploration of territory between the Rocky Mountains and the Sierra Nevada." With the enthusiastic backing of Stanton and Senator John Connes of California, Congress authorized an appropriation of $100,000 to establish the Geological Explorations of the Fortieth Parallel under the overall direction of the War Department. Five days after the appropriation was passed by Congress, President Andrew

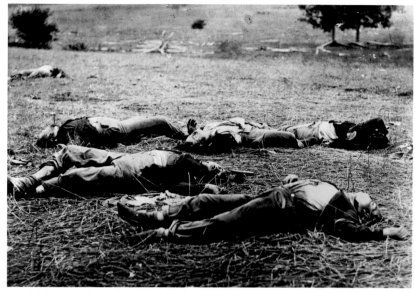

"Field Where General Reynolds Fell," July 1863

Johnson appointed King United-States-Geologist-in-Charge of the expedition. King outlined the scope of the expedition's interests on the first page of *Systematic Geology*, the first volume of the seven-volume (not counting atlas) *Final Reports*: "The explorations of the Fortieth Parallel promised, first, a study of the natural resources of the mountain country near the Union and Central Pacific railroads; secondly, the completion of a continuous geological section across the widest expansion of the great Cordilleran Mountain System."[15]

The government had several immediate needs. First, it wanted a thorough accounting of this vast and largely unexplored area. Large deposits of coal had been reported in the eastern region of King's proposed route, and the expanding western section of the country needed a local source of coal. Major strikes of silver and gold were being worked in the region, and the extent and nature of these deposits were

largely unknown. And the army required accurate maps, since immigration along the route of the railroads was increasing, and with it the hostility of the native Indian population to the incoming aliens.

King's plan was grand—to explore a hundred-mile-wide swath from the eastern slopes of the Sierra Nevada Mountains, across the vast American wilderness—the

Clarence King, c. 1868, attributed to A. J. Russell

Great Basin—to the Rocky Mountains. King's interests were diverse. As a scientist, he saw the exploration as an opportunity to produce an accurate description of the geology of the region with the ultimate aim of finding the basis for an explanation of how it came into being. This was not an altogether dispassionate, scientific interest by modern standards. King's geology, theology, and esthetics inter-

mixed and formed a comprehensive system. He rejected "uniformitarianism," the prevalent view of the time concerning geological development. This doctrine holds that the processes of geological action have been the same throughout time. Since modern geological processes are so slow as to be virtually undetectable, uniformitarians maintain that all changes in the earth's surface have occurred over aeons. King did not deny that some geological periods were slow and uniform—he believed that the modern period was such a time—but he believed that periods of slow change were shattered by periods of catastrophic, life-threatening upheaval. He saw such periods as the work of God, forcing the planet into new geological forms and compelling animate life to "change or die." For King, periods of catastrophic change were periods of Divine Creation. Geology was not only the study of the history of the earth, it was the history of God's continual and awful recreation of the earth.

King hired O'Sullivan in April 1867. No records explain why he chose O'Sullivan from the group of photographers working in Washington and New York and on the West Coast, although O'Sullivan certainly had the credentials, as a reliable field photographer and as a proficient copyist of maps and documents. But King was looking not only for a technician, but a maker of pictures—if not an artist, then an artisan.

King's interest in art was broad and profound. At the age of twenty, he had been one of the founding members of The Society for the Advancement of Truth in Art, the American Ruskinite Society. He agreed with Ruskin's stipulation that an artist must possess an intimate knowledge of geology, meteorology, and botany, as well as an exquisite sensitivity

to the divine significance in all of nature. For Ruskin, a great artist had to combine observation of the most minute scientific particular with the ability to express the great ideas inherent in nature that transcend particulars. In Ruskin's writings, King found a near worship of accurate observation and documentation enmeshed in a doctrine of the ideality of nature. In his descriptions of geological formations, King writes with an appreciation of art. And he knew that the Fortieth Parallel explorations would immediately descend into the Great Basin, which seemed to him to be filled with reminders of a remote war beyond the memory of man.

In 1866 he had journeyed by mule, with his friend James Gardner, across the desert that lies immediately to the east of the Sierras — the same land that he was about to explore in 1867. He wrote:

> Spread out below us lay the desert, stark and glaring, its rigid hill chains lying in disordered groupings, in attributes of the dead. The bare hills are cut out with sharp gorges, and over their stone skeletons scanty earth clings in folds, like shrunken flesh: they are emaciated corpses of once noble ranges now lifeless, outstretched as in a long sleep. Ghastly colors define them from the ashen plain in which their feet are buried. Far in the south were a procession of whirlwind columns slowly moving across the desert in spectral dimness. A white light beat down, dispelling the last trace of shadow, and above hung the burnished shield of hard, pitiless sky.[16]

Throughout King's writings he characterizes the West in terms of sharp oppositions between the hospitality and "grace" of places like Yosemite Valley, California, and the inhumane and terrifying aspects of places like Shoshone Falls, Idaho. The explorations along the Fortieth Parallel were ultimately aimed at the study of traces of the marks of raw power and the evidence of violent, explosive rates of change that could account for the corrugations and crumplings of massive mountain chains and the production of vast sand-filled deserts that had once been inland oceanic seas. The human counterpart of explosive, natural action is war. As a photographer of a holy war in which a nation tore itself apart and was told to "change or die" — a photographer of the aftermath or traces of war, of mangled corpses and fields that imply, but do not show, the fleeting presence of the terrible force of destruction — Timothy O'Sullivan seems not merely appropriate, but inescapably fitting for the job as King's photographer.

O'Sullivan's salary was $100 a month. He immediately composed a memorandum listing the articles he would need as expedition photographer. Characteristically, he turned to his old friend Lewis Walker to assist him in the selection. The list was sent to King who in turn passed it on to his immediate supervisor, Brigadier General A. A. Humphreys, Chief of the Army Corps of Engineers. He wrote,

> I have the honor to transmit a memorandum of Photographic material which I have decided upon after consulting with Mr. O'Sullivan and Mr. Walker, with the request that they may be delivered to Mr. O'Sullivan in New York, who follows me to California sailing on May 10th. I also desire that the larger camera may be made under Mr. O'Sullivan's direction by Anthony & Co. of New York.

Memorandum of Photographic Instruments and Material required for Geological Exploration of the 40th Parallel

1 Camera box for 9 × 12 plates
1 Tripod stand for same
1 Camera for stereoscopic views
1 Table for 9 × 12 views by Zinburger of Philadelphia
75 English patent plates 9 × 12 in boxes of 25
50 English patent plates 8 × 10 in boxes of 25
1 Extra plate box to contain 25 plates for each size, viz.,
 9 × 12 and 8 × 10
1 Hard rubber bath for 9 × 12 plates, with 2 dippers
2 Hydrometers for silver solutions
1 Eight ounce fluid measuring glass
1 Glass filter and 2 packages of 13 mm filter paper
1 Small photographic tent
1 Plate holder for cleaning plates 9 × 12
1 Plate holder " " " 8 × 10
6 Pounds Nitrate of silver
3 " Rotten stone finely powdered
6 oz. Iodide of Potassium
3 " " " Cadmium
3 " Bromide
3 " " " Ammonium
6 " Crystallized Iodine
5 Pounds Cyanide of Potassium
4 " Negative Varnish
1 Black cloth for focus shade.[17]

O'Sullivan's request to supervise the construction of the large plate camera was typical of the care that he took with all of his work on the expeditions and of his pride in his craft. A camera off the shelf would not do. He needed one that was light enough to be transported in the field, but that had been reinforced to withstand the rigors of field work.

The list is not quite complete and its omissions are curious. O'Sullivan does not list collodion or its constituent components, ether, guncotton, and alcohol. Nor does he list pyrogallic acid, ferrous sulphate, and acetic acid, the necessary ingredients for developing wet plates. Perhaps he feared transporting the liquids, collodion and acetic acid, because the bottles might have broken in shipping. Collodion is highly flammable and acetic acid is mildly corrosive. But even if these items were excluded for obvious reasons, transportation problems hardly explain why two crystalline substances, and essential ones at that, pyrogallic acid (which is only mildly acidic) and ferrous sulphate (a harmless substance) were omitted. If O'Sullivan planned to purchase these materials in San Francisco, he probably could have obtained all the other chemicals there as well. The omission of albumen paper, gold chloride, bicarbonate of soda, and all the other necessary materials for printing is another matter. O'Sullivan never printed in the field. He judged exposure on the spot by eye, and he judged the geological and pictorial merit of the negative in the same way.

On 11 May 1867 King, together with O'Sullivan and three other members of the expeditionary group, sailed for Aspinwall in Panama. At Aspinwall, they took the narrow-gauge railroad across the Isthmus of Darien to Panama City, where they embarked on a sidewheeler for San Francisco, which they reached on 3 June. O'Sullivan collected his materials and equipment that had been shipped ahead, purchased an ambulance and converted it to a portable darkroom, acquired four mules for pulling the wagon and to be used for carrying equipment when the wagon proved impractical, and moved on to Sacramento, California, where the group assembled to prepare for the ascent of the western slope of the Sierras. On 3 July, they began the climb. The enormous labors required to cross the Sierras proved to be a foretaste of the arduous expedition life that

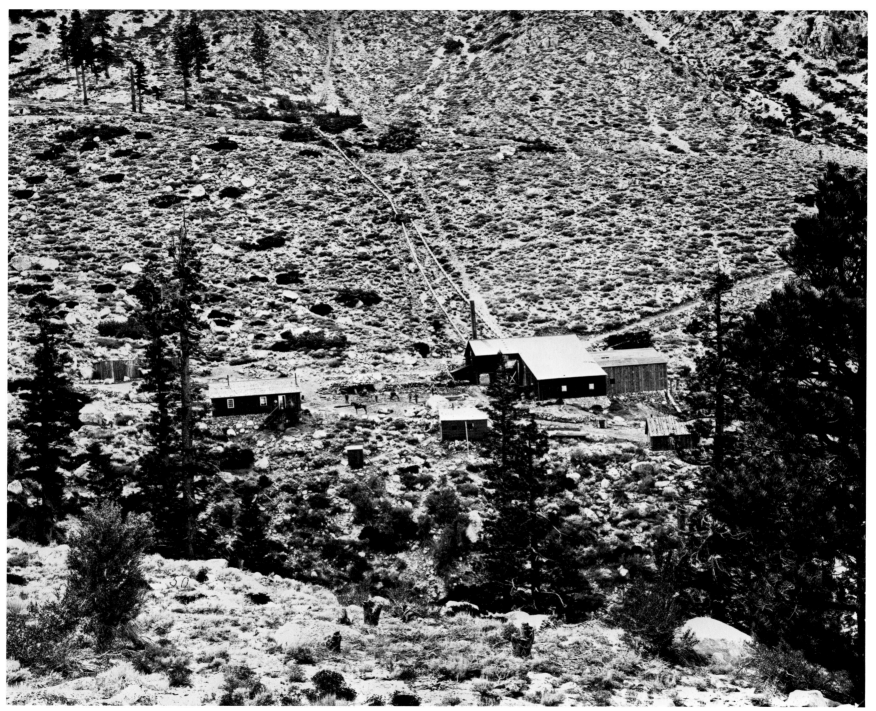

Kearsage Mining Company, Kearsage, California, 1871

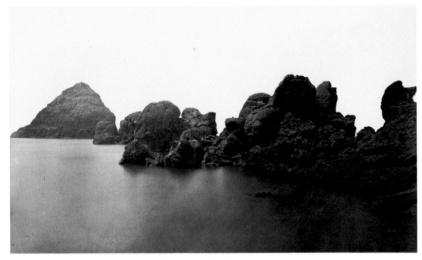

Tufa domes, Pyramid Lake, Nevada, 1867

O'Sullivan would lead for the next seven years. In a terse letter to Humphreys, reporting the start of the Fortieth Parallel explorations, King wrote,

> The [wagon] train marched across the Sierra Nevada by the Donner Pass in eleven days, resting on Sunday and remaining at Cisco [California] a day to have some loose irons on the wagons repaired.
>
> The snow on the summit was eight feet deep. July 14th, the expedition reached the lower edge of the great meadows of the Truckee near the entrance of the cañon which the river has cut across the Virginia Range of mountains.[18]

Moving through the Donner Pass was treacherous, because, as O'Sullivan later reported, the snow was so wet that they had to move at night when the mountain air froze it into a crust firm enough to support them. Even with such precautions, men often disappeared into the huge snow drifts and had to be rescued.

O'Sullivan began to photograph in the Truckee Meadows and was assigned to a party led by the Swiss-born topographer Henry Custer, who was one of two topographers with the group. King did not accompany Custer's group on their explorations, which included a horrifying voyage down the Truckee River in a boat named *Nettie*, which had been acquired for the group by the local Indian agent, H. G. Parker. Most likely Parker did not tell Custer that the Truckee had never before been navigated. On the way downriver to Pyramid Lake, Nevada, the boat was abruptly jammed against two volcanic rocks by the furious current. It would not move, and the crew feared that dead tree trunks, pushed at enormous velocity by the river, might smash into and splinter the *Nettie*. O'Sullivan "divested himself" of nearly all his clothes and jumped into the rushing river.

> Being a swimmer of no ordinary power, [he] succeeded in reaching the shore, not opposite the *Nettie*, though it was but forty yards from the shore, for he was carried a hundred yards down the rapids. . . . The sharp rocks . . . had so cut and bruised his body that he was glad to crawl into the brier tangle that fringed the river's brink. When at last he gained the point nearest the boat his excited friends threw shoreward his pocketbook, freighted with three hundred dollars in twenty-dollar gold pieces. "That was rough," said he, "for I never found that 'dust' again, though I prospected a long time, barefooted, for it."[19]

If O'Sullivan and the rest of the men had come West with a view of a benificent, hospitable nature, they certainly lost it on the trip. *Nettie* was guided down the remainder of the river with ropes held by men on shore. And then they came

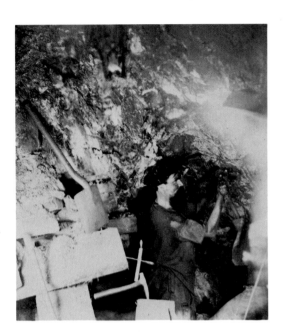

Above left, miner at work 900 ft. underground, Gould & Curry mine, Virginia City, Nevada, winter 1867–68; *right*, crash of timbers in cave-in, Gould & Curry mine, Virginia City, Nevada, winter 1867–68; *below left*, Pamranaset Lake district, Nevada, 1871; *right*, ore carriers, Virginia City, Nevada, winter 1867–68

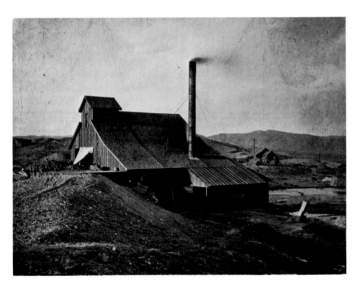

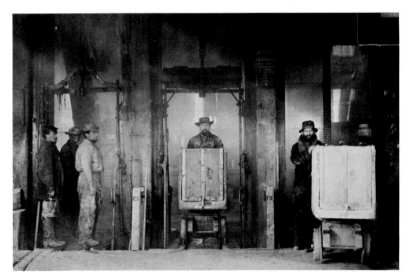

to Pyramid Lake. O'Sullivan's photographs of the volcanic islands on the lake are stunning. The grotesque forms of volcanic rock appear to grow from the water like menacing fungal growths. The color of the rocks varies with the light, and O'Sullivan photographed the formations in a variety of light conditions so that they appear black in some prints and pale gray in others. In some exposures, O'Sullivan purposely underexposed the plates so that the water is just barely visible and the rocks appear to mushroom from empty spaces.

The field work in the summer and autumn of 1867 took the team throughout western Nevada. Although the expedition accomplished much work, nearly all of the men came down with malaria, carried by the huge swarms of mosquitos that were ever-present companions. At one time, only O'Sullivan, who never contracted the fever, and one other member of the party were well enough to continue their work.

In the winter of 1867—68, O'Sullivan and the rest of the expedition party worked at both Virginia City and Carson City, Nevada, while King returned alone to San Francisco. In Virginia City, O'Sullivan photographed the gold- and silver-mining operations and made a series of descents of several hundred feet into the deep mines. In the mines the temperature reached 130 degrees Fahrenheit, and men could work for about one-half hour at most before returning to the surface. O'Sullivan used his stereo camera to make photographs in the claustrophobic mines, illuminating the "caves" with intensely bright magnesium ribbons. These were among the first subterranean mining pictures ever made and the first made in America. The technical achievement of working the wet-plate process in severely cramped and intensely hot quarters is impressive in itself;

the strong pictorial quality of the results make the accomplishment even more remarkable.

O'Sullivan's technical achievement is consistently impressive. In addition to the single-plate landscape views that he usually made, he also made a number of striking multiple-plate panoramas, apparently without the aid of the panoramic tripod attachment that greatly simplifies the

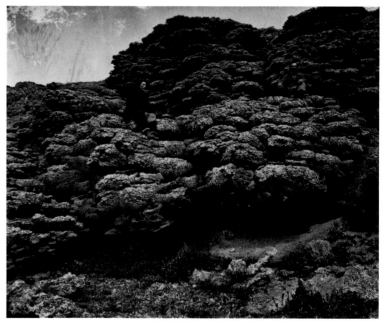

Lime tufa formations, Nevada, 1867

problem of matching the edges of overlapping plates. The first two-plate view that he made in the West was of an alkali lake near Ragtown, Nevada, during the 1867 season (page 60). From time to time during the next seven years, O'Sullivan made a number of two-, three-, and even four-plate panoramas that were only rarely printed and mounted together as panoramic views. A number of individual photographs that were conceived as part of a larger whole were

published as single prints by both the King and Wheeler surveys.[20]

In the spring of 1868 field work began again, and O'Sullivan continued to photograph in western Nevada, worked at Mono Lake, California, and in the East Humboldt Range, and then took a trip beyond the northern outer limits of the hundred-mile-wide belt under exploration by the Fortieth Parallel expedition. He and King journeyed to the Snake River and Shoshone Falls in southern Idaho. King was alternately attracted and repelled by the blackness and power of the falls. Despite his revulsion, he slept by the falls' edge and, for hours in the darkness, watched the rushing water, illuminated by the moon whenever it was not covered by clouds. O'Sullivan, too, was deeply impressed by the "weird forms" created by the "constant action of rushing water" and particularly the view from behind the falls, where he could not see the falling water but could hear the roar "and gaze down stream over the fall at the wild scene beyond."[21] In addition to this scene, O'Sullivan photographed the falls from below, looking directly into the menacing sheet of falling water.

In October 1868 O'Sullivan traveled back to Washington. King had specially arranged for the use of Treasury Department photographic rooms, and with the assistance of Walker, O'Sullivan began printing two sets of the photographs from negatives that had been taken during the two previous summers of surveying. The prints were used for internal purposes but were not published. During the fall and winter furlough from the expedition O'Sullivan began to court Laura Virginia Pywell, daughter of R. R. Pywell and the sister of William Reddish Pywell, a photographer of fine reputation in Washington who had worked for Brady and who is represented in the *Sketchbook of the War*. The Pywell family album contains a carte-de-visite portrait of O'Sullivan taken by Gardner. On the back of the card Laura Pywell had written "Given to me by Mr. Sullivan on December 5, 1868."[22] This courtship was to last five years.

The survey of 1869 originated in Salt Lake City in May. O'Sullivan began the season by photographing the Great Lake and then photographed in northern Utah and southern Wyoming. During this period, O'Sullivan worked directly with King in the Wasatch Range and the Uinta Mountains photographing the rugged peaks and the picturesque mountain lakes that King had taken to christening with the names of his sister and her friends. During the 1869 field survey O'Sullivan produced some extraordinary images in the Weber and Echo Canyons and in Provo. At the close of the season in September King ordered the equipment and livestock sold at auction, since his initial appropriation had run its limit of three years. He hoped that he could return to the field, but, without funding, that hope seemed groundless, and the men made their way back east.

When O'Sullivan returned to Washington, he must immediately have started looking for new employment. It wasn't long before he found it. The Navy Department was about to initiate an expedition to the Isthmus of Darien in the State of Panama, which was then part of Colombia. At the same time that O'Sullivan received assurance of this position, King had just learned that his friends in Congress had convinced the War Department to send him back to the West. Humphreys ordered King back into the field, and he had to return to California without O'Sullivan, who, suitably equipped by the Navy, had sailed for Darien in January 1870.

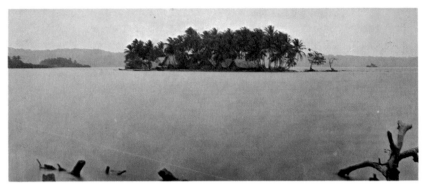

Isthmus of Darien (Panama), 1870

O'Sullivan was hired at a dual rate—$5 a day while in the United States and $7 a day while out of port. His pay had increased from $100 a month while working for King to a monthly rate that varied between $150 and $210. O'Sullivan sailed on the U.S.S. *Guard* under the command of Captain E. P. Lull. His orders stated that he would mess and quarter with the officers and that he would "conform to all the rules of Naval discipline." The Navy may have hired O'Sullivan not only for his experience as a survey photographer, but because he had already passed through Panama on his way to San Francisco and would have been familiar with the difficulties of the tropical terrain. O'Sullivan worked with Lull on the Atlantic side of the Isthmus from February to June. The project proved frustrating because of the dense tropical foliage that obscured the very features of the landscape that O'Sullivan was assigned to photograph. O'Sullivan made a number of views in Panama and seems to have concentrated primarily on the activities of the crew. The Navy never issued an official set of views from the expedition, though it did issue a set of pictorially undistinguished stereographic cards. During the survey of 1871 the Navy hired John Moran, a photographer from Philadelphia

and brother of the painter Thomas Moran, to replace O'Sullivan. Many of Moran's prints have been misattributed to O'Sullivan—especially the views of the Limon River and Limon Bay. (O'Sullivan never visited Limon Bay, which is on the Pacific side of the Isthmus.)

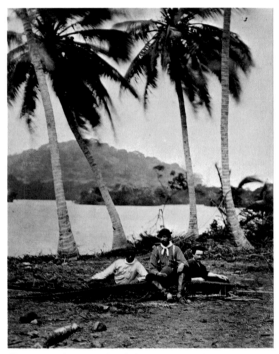

Crew members of the Selfridge expedition to Darien (Panama), 1870

O'Sullivan returned to Washington in July 1870. He spent the next two months making prints of a selection of the views he had made while on the King survey. Again he printed in the Treasury Department facilities with the assistance of Walker, who, under contract to King, also copied a number of large maps on 19-×-23-inch negatives and printed a set of the photocopied maps for inclusion in the atlas.

At the same time that O'Sullivan was working on the

prints for King, he was approached by Lieutenant George Montague Wheeler, who had been in charge of an army reconnaissance in Nevada and Utah in 1869 and had just been made chief of an exploration of "territory lying south of the Central Pacific Railroad, embracing parts of Eastern Nevada and Arizona."[23] Wheeler wanted O'Sullivan to accompany him to the Southwest as photographer to the expedition. The army was unhappy with what it saw as a usurpation of its traditional role as the nation's explorers by civilians like King, F. V. Hayden, and John Wesley Powell. Moreover, army men like Wheeler believed that the civilian-run expeditions concentrated too much on theoretical investigation and not enough on the preparation of accurate maps of inhabited areas.

It appears that once the Navy Department removed O'Sullivan from the payroll, he immediately returned to King's staff, since Wheeler had to approach King to obtain his permission for O'Sullivan's services. As King later recounted in a note to Humphreys, "At the earnest request of Lieut. G. M. Wheeler, I gave him my photographer, Mr. O'Sullivan"[24] Wheeler, who was also under the direct command of General Humphreys, wrote the General in September 1870: "Upon making my first requisition for employees, there was no person then in view who could fill in a competent manner the above position [of photographer] This gentleman [O'Sullivan] has been for some time employed by Clarence King, has large experience, and in case that his services can be obtained, it is judged that his addition to the number of assistants will result in a valuable set of views illustrating the nature of the country, especially in the vicinity of the Cañons of the Colorado, since no regular artist will be attached."[25]

O'Sullivan earned $150 a month. The expedition began on 3 May, setting out from Halleck Station, Nevada. In terms of seniority based upon time served surveying in the West, O'Sullivan ranked first. Accordingly, Wheeler immediately placed great trust in him. In Special Order Number 3, written on 15 May, he wrote, "In order to relieve Mr. Gilbert [Grove Karl Gilbert, geologist to the expedition] partially from responsibility and also to give him more opportunity to attend to his personal labors, Mr. O'Sullivan is hereby detailed to assist him with co-equal powers of authority in the execution of the work called for. Mr. O'Sullivan will take his photographic apparatus."[26] Throughout the period he employed O'Sullivan, Wheeler granted him authority to lead groups on explorations as well as to purchase supplies.

This survey proved to be the most difficult of all those with which O'Sullivan served. The work began with coverage of mining districts in Nevada and then moved across Death Valley, California. Wheeler routinely ordered forced marches that began in the early morning and ended the following morning. The heat was extreme, often reaching 120 degrees Fahrenheit. O'Sullivan managed to make photographs despite the heat and despite the marches, which on one occasion ran eighty hours "with scarcely a single halt."[27] In mid-September the party reached Camp Mohave, California, and stopped to rest before beginning an even more difficult trek than the one across Death Valley — the group was to journey by boat *up* the Colorado River to Diamond Creek in the Grand Canyon, a distance of more than two hundred miles against a powerful current. On 16 September, the group split into three parties, with Wheeler, Gilbert, and O'Sullivan each in charge of a boat. Gilbert

named his boat *Trilobite*, O'Sullivan named his *Picture*, and the taciturn Wheeler did not christen his at all. Wheeler placed O'Sullivan on a "roving commission" to photograph the canyons at his own pace and, consequently, he tended to lag behind the other two boats. The boats were rowed, pulled by line, and sailed, when the wind allowed, upriver. On 21 September, Gilbert wrote in his diary, "The wind was of great service today carrying us along gaily except at three or four rapids. *Contra*: it interfered with photography and kept O'Sullivan in a perpetual state of profanity."[28] On 22 September, the group entered the chilling Black Canyon, and Wheeler wrote in his diary, "the moon is now so far increased that the last two evenings in the Black Canyon have been most picturesque and lovely."[29] Further up the Canyon, his tone changed, and he wrote that there are "points at which stillness, like death creates impressions of awe."[30] O'Sullivan's photographs of the Black Canyon begin drenched in light, progress into an abyss of blackness where human figures can barely be made out, and emerge again into the light.

The task of hauling the boats was bone-crushing. On 25 September, Gilbert wrote, "O'Sullivan's hand so sore that we make no pictures here."[31] The ascent proved a near disaster. Wheeler's boat, with all of his personal and scientific notes, was smashed against the rocks and lost. The group had to finish in two boats. It took thirty-three days to complete the journey—an average of six miles a day. At Diamond Creek, the final destination of the ascent, O'Sullivan photographed the crews standing by the remaining boats. Perhaps to prove to the world that he had made the trip, he included himself in one of the photographs.

The group descended the river in just five days and returned to Camp Mohave, where they rested and then continued work through mid-December. O'Sullivan returned to the east by way of San Francisco and reported to Wheeler in Washington on 15 January 1872. Of the negatives he brought with him many were broken en route, including, according to Wheeler, many of the best views of the Grand Canyon. The remarkably high quality of the remaining negatives makes this assertion hard to believe.

Wheeler was delighted with O'Sullivan's work. "By dint of hard labor," he wrote, "more than 400 negatives have been produced of scenery in every way unique and grand. The series illustrative of the section of country found in this wild and desolate region is fine and many of the geological views will be interesting and instructive."

In Washington, O'Sullivan began printing the results of the season's work. He was also asked to make prints from the King negatives for the Library of Congress.

On 18 December 1871 King had written Humphreys requesting that he be permitted to rehire O'Sullivan. The request remained unanswered while Wheeler waited to hear if he would be sent back west the following summer. By March, the bill for Congressional appropriation in support of Wheeler's field work had not been acted upon, and Wheeler wrote King,

> Sir,
> From and after the time that you will receive this communication the arrangement for the transfer to your Survey of Mr. O'Sullivan's services, with his consent, can be made. Since there are no really further duties for him, unless an extended exploration is projected for the ensuing season, it is desirable that this transfer should be made at once.[32]

O'Sullivan did consent and by the time that Wheeler learned that a Congressional appropriation had been made for the Geographical Surveys West of the One Hundredth Meridian, with himself in charge, O'Sullivan had already been in the West with King for over a month. Wheeler quickly found William Bell, a photographer from Philadelphia, to replace O'Sullivan for the season.

O'Sullivan began the last year of work for King on 1 May. As early as the previous December, King already had planned for O'Sullivan to work mostly on his own in 1872. He had requested two photographers from Humphreys: Carleton Watkins to accompany him to California and to photograph "volcanic work" in California, and O'Sullivan to go alone to "Wyoming on the cañon trip," and to photograph "a new and extremely picturesque occurrence of *Mauvaises Terres*." As it turned out, King had to forego the services of Watkins because of heavy snows, and decided to work with O'Sullivan in the High Sierras before sending him on to Wyoming. O'Sullivan found King encamped in Merced County, but snow made the Sierras impassable. King was never able to make his studies of volcanic action. Instead, he had to invent some "make work" for O'Sullivan, sending him off to photograph along the railroad between Elko, Nevada, and Ogden, Utah, to make "detail views of the Tertiary Bluffs until the Green River falls sufficiently to permit him to begin his trip down the great cañons."[33]

Finally, in August, O'Sullivan made the journey to southwestern Wyoming and northwestern Colorado, where he photographed the Green River Canyon, Flaming Gorge, the Washakie Badlands, and the Gate of Lodore. O'Sullivan returned to Washington in late November, with special plans for the next year. On 11 February 1873 O'Sullivan married

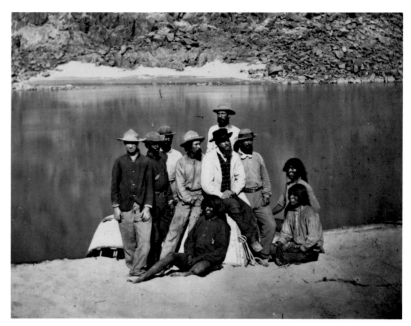

Crew of the *Picture* with O'Sullivan (fourth from left) seated next to Lieutenant George Montague Wheeler, Diamond Creek, Colorado, 1871

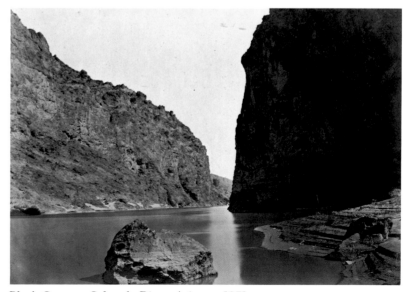

Black Canyon, Colorado River, Arizona, 1871

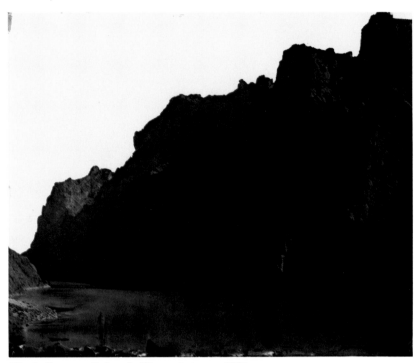

Black Canyon, Colorado River, Arizona, 1871

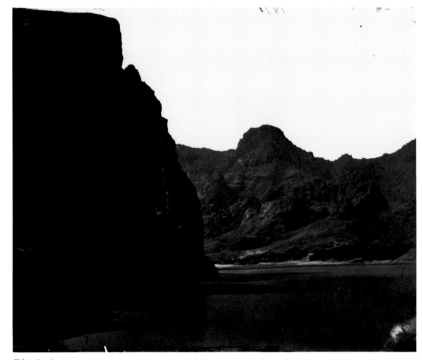

Black Canyon, looking below near Camp 8, Colorado River, Arizona, 1871

Laura Virginia Pywell in the E Street Baptist Church in Washington. Since O'Sullivan was still engaged in survey work and since the *Washington Directory* does not list him until 1876, Laura O'Sullivan probably continued to live in the Pywell family home until her husband's final return to Washington.

During the winter of 1873, O'Sullivan printed sets of photographs for both King and Wheeler. He made sets for each survey to be sent to the American Geographical Society in New York for transmission to the Vienna Exposition that was to open in May 1873. At the same time, Wheeler received five hundred dollars in appropriations from the Secretary of War for O'Sullivan to print four sets of prints from the 1871 and 1872 negatives.

Wheeler rehired O'Sullivan for the 1873 season at $175 per month. The survey worked extensively through Arizona and New Mexico covering the Sierra Blanca Mountains, Canyon de Chelly, and the eastern edge of the Grand Canyon. O'Sullivan spent a large amount of time photographing Indians in the pueblos around Santa Fe and in Arizona. He was given "executive charge" of side parties and supervised a triangulation team that surveyed between Santa Fe and Fort Wingate, Arizona. He returned to Washington in October and immediately began printing from both King and Wheeler survey negatives.

In May 1874 the Secretary of War approved an expenditure of $5,000 for printing official sets of Wheeler survey photographs. Julius Bien & Company, a New York

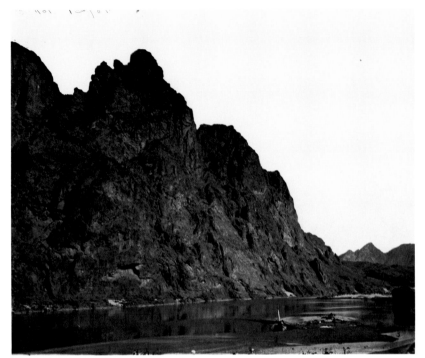

Black Canyon, Colorado River, Arizona, 1871

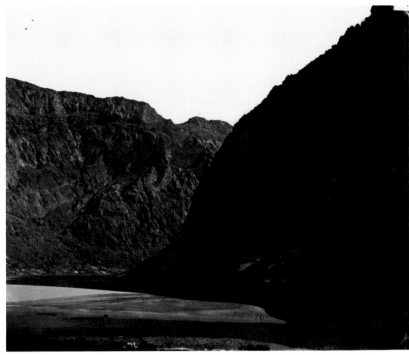

Entrance to the Black Canyon, Colorado River, Arizona, 1871

lithographic firm, produced the mounts for the prints; Collins, Son & Company of Philadelphia printed the stereograph mounts; and the Government Printing Office provided the captions to accompany the mounted prints. In the same month, O'Sullivan quit Wheeler's staff and began to print the photographic sets under contract to the Corps of Engineers. O'Sullivan was paid at the rate of $80 for each one thousand stereos and $90 for one thousand large views. Apparently he had not calculated the economics of this work, for the next year he had to ask for $20 per hundred for the views. It is not known where he did the printing, but it is likely he did much of it in the studio of his brother-in-law William Pywell.

In July, O'Sullivan, with the printing still incomplete, re-joined the Wheeler survey and journeyed to the West for the last time. He worked throughout northern New Mexico and in Colorado and turned again to photographing Indians and their dying way of life. At the end of the season in November, he traveled alone, with Wheeler's blessings, through Ogden, Utah, to Shoshone Falls in Idaho. He spent at least three days at the falls photographing it from a variety of vantage points. Most likely he knew he would not return to the West for a long time, if ever. In fact, these were the last photographs he made in the West, after an odyssey that had taken seven years and covered tens of thousands of miles. The scenes of Shoshone are dark emblems of all that is expressed in his work.

On his return to Washington O'Sullivan reinitiated his

printing work, again on contract to Wheeler. In addition to the 1871–73 series, he printed a series that covered 1871–74. On 11 November 1875, in one of the few letters known to be in O'Sullivan's hand, he petitioned Wheeler

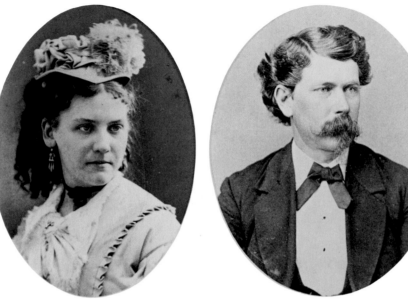

Laura Virginia Pywell,
c. 1868, by Mathew Brady

Timothy H. O'Sullivan, c. 1873.
E. Marshall Pywell collection

for the use of the negatives on a royalty basis, so that he could publish the work for sale to the general public. He wrote,

I have respectfully to request permission to make prints to be mounted in the usual form from a number of selected negatives, stereoscopic and landscape, not exceeding 100 of the former and fifty of the latter, obtained in connection with your survey during the time which I was engaged under your orders as photographer. Many persons have suggested that arrangements should be made with the Engineer Department, whereby authority to publish with a view to provide for the sale of pictures from the above negatives, should be obtained to the end that the general public might be able to obtain at a reasonable price these views that represent to some extent the country through which your several commands passed in the mountainous regions of the west.

It would be a matter of Pride to me having been engaged upon the spot in the production of most of these negatives in connection with your several arduous expeditions, to see that these pictures are produced in the highest style of the photographic art, and that such means shall be adopted for their sale as will insure that they will naturally reach those persons most interested in the prosecution of works of this kind. . . .[34]

The petition had to travel up the chain of command in order to receive ultimate approval from the Secretary of War. Wheeler wrote Humphreys a note approving the request and noted, "Mr. O'Sullivan would be more likely to produce prints from these negatives in a manner commensurate with their value than any other person and it is believed that the means he will provide to enable persons specially desirous of obtaining them will be entirely satisfactory."[35] The petition was granted with the provision that O'Sullivan first complete the printing of the 1871–73 series and the 1874 survey photographs before he start work on his own. For some reason, though he fulfilled this last stipulation, O'Sullivan never carried out his plan for independent publication.

In 1876, O'Sullivan appeared in the *Washington Directory* as a photographer boarding at 318 Indiana Avenue.

Shortly thereafter his wife, Laura, became pregnant. Between the income from Wheeler for his printing and perhaps from "free-lance" photographic assignments from his brother-in-law and his many friends, O'Sullivan must have been looking forward to a reasonably prosperous and perhaps celebrated future. But things took an immediate dark turn. On 13 September 1876 Laura delivered a son, stillborn. The records at the Rock Creek Cemetery in Washington show that there was no officiating minister and not even an undertaker for the infant's funeral. O'Sullivan must have buried the infant himself in the Pywell family plot. He continued to work in Washington in 1877, and in 1878 he was listed in the *Washington Directory* as part of "Armstrong & Co. [William J. Armstrong and Timothy H. O'Sullivan] photographers, 818 F, N.W." But the good fortune that had followed him from his late adolescence through all his "arduous" survey work had come to an end. Even Wheeler, always a man who went by the army book, seemed to turn on him. On 28 April 1878 Wheeler wrote O'Sullivan,

> Will you have the kindness to turn over to Mr. McChesney such articles of property (that is, photographic instruments and apparatus) for which I am responsible and which you now have in your hands, borrowed from this Office in the spring of 1877. It is imperatively necessary that these instruments should be returned and placed at once upon the inventory list.[36]

O'Sullivan worked through 1879 and 1880 on his own, having severed his connection with Armstrong & Company. In July 1880 he was temporarily appointed by Clarence King to the new United States Geological Survey office as photographer at one hundred dollars a month. It is not clear what his duties were, but the total outlay for photographic materials by the USGS in 1880 was a mere $6.75, hardly enough for a large amount of work. In October 1880 O'Sullivan's "bosom friend" Lewis Walker died. In November, after arranging for letters of recommendation, O'Sullivan applied for Walker's old job. Warm endorsements arrived from Gardner, Brady, John Wesley Powell, and E. P. Lull, among many others, and King sent a telegram from San Francisco. The letters praise O'Sullivan as an expert photographer and technician, as a responsible administrator, and in the words of Commander Lull, as "an especially desirable associate."[37] On 6 November O'Sullivan signed an official declaration of allegiance to the United States and became photographer to the Department of the Treasury.

Just about this time O'Sullivan learned he had phthisis (tuberculosis) of the lung. In March 1881, less than six months later, O'Sullivan was forced to resign his post at the Treasury. In September, he left Washington to convalesce at his parents' home on Staten Island, New York. In October, he received another terrible shock, when Laura O'Sullivan died of tuberculosis in Washington. He journeyed to Washington and attended the funeral of his wife, whose grave at Rock Creek Cemetery lies under an enormous and ancient burr oak. Soon after the funeral, he returned to Staten Island, telling his friends that he would return shortly before the Christmas holidays. But in mid-December the tubercules in his lungs began to hemorrhage. Still on Staten Island on 22 December, he was placed under a physician's care.

On 14 January 1882, O'Sullivan died at the age of forty-two. The cause of death on the certificate, which refers to

him as "Timothy H. Sullivan," is noted as pulmonary tuberculosis, "Phthisis Pulmona Cis." On 17 January he was buried in Saint Peter's Cemetery on Staten Island. The entry in the church cemetery records identifies him as "Tim Sullivan." Today nothing marks his grave.

Death of a Washingtonian

Letters have been received in this city announcing the death of T. H. O'Sullivan, Esq., which occurred on the 14th instant in New York State. He was at one time prominently connected as photographer to the Wheeler Expedition and subsequently held the position formerly had by [Lewis E.] Walker in the Treasury Department. But a few months since, he was called to this city to attend the funeral of his beloved wife, a daughter of Mr. and Mrs. R. R. Pywell. Although not in the best of health when he left for New York, he fully expected to return here to spend the holidays. His many friends (who were numerous) will be pained to hear of his sudden demise. Mr. Sullivan [sic] was a native of New York.

From a typewritten copy of an undated and unidentified newspaper obituary in the records of the Pywell family kept by E. Marshall Pywell

1. Treasury Department job application, 6 November 1880, signed by O'Sullivan, Records of the United States Department of the Treasury, National Archives.
2. State of New York, Certificate of Death 16397–304, filed 15 January 1882, County of Richmond, Town of Castleton (New York State Department of Health, Albany, New York).
3. "It is a bit singular that Sullivan has never written a word since he left although he promised to do so within ten days of his departure from W[ashington] — Can you give me any tidings of him?" Lewis E. Walker to Clarence King, 7 March 1871, Record Group 57–M622–1, National Archives.
4. Baptism and Marriages 1839–1888, Saint Peter's Church, New Brighton, S.I. N.Y., last p., s.v. "Confirmations."
5. In his 1880 recommendation of O'Sullivan for the job in the Treasury Department, Alexander Gardner noted that he had provided a recommendation for Lewis Walker for the same post twenty-four years earlier. (The original recommendation has not been located.) In O'Sullivan's application for the job at the Treasury, he noted that he had been "bosom friends" with Walker for twenty-five years. Since Walker was in Washington at the outset of the friendship, the two men probably met there. See Records of the United States Department of the Treasury, National Archives.
6. John Samson, "Photographs from the High Rockies," *Harper's New Monthly Magazine* 39, no. 232 (September 1869): 465. O'Sullivan is not named in this article, but he is clearly the photographer referred to in it. John Samson appears to be a pen name; the writer was probably a member of the Fortieth Parallel survey group. An inviolable rule of the Chief of the Army Corps of Engineers, General A. A. Humphreys, prohibited members of the survey from publishing prior to the publication of the final reports. The Fortieth Parallel survey is not mentioned by name in the article.
7. Treasury Department application, 6 November 1880, Records of the Department of the Treasury, National Archives. In answer to questions about armed forces experience, O'Sullivan replied, "In the army . . . As 1st Lieut. on Genl. Vielie's [sic] Staff 6 months. Was honorably discharged at Hilton Head, S.C., in May, 1862."
8. The most complete account of O'Sullivan's work dating from the beginning of the war through the summer of 1863 appears in Alexander Gardner, *Catalogue of Photographic Incidents of the War from the Gallery of Alexander Gardner* (Washington, D.C.: H. Polkinhorn, Printer, September 1863). A copy of this extremely rare booklet is in the Library of Congress, Washington, D.C.
9. Alexander Gardner, *Gardner's Photographic Sketchbook of the War*, 2 vols. (Washington, D.C.: Philp and Solomons, Publishers, n.d. [1866]).
10. Ibid., pl. 36.
11. Ibid., pl. 37.
12. Ibid., pl. 40.

13. Ibid., pl. 41.
14. In the preface to the *Photographic Sketchbook*, Gardner wrote, "Localities that would scarcely have become celebrated, and will ever be held sacred as memorable fields, where thousands of brave men yielded up their lives, a willing sacrifice for the cause they had espoused."
15. Clarence King, *Systematic Geology*, Professional Papers of the Engineer Department, U.S. Army (Washington, D.C.: U.S. Government Printing Office, 1878), p. 1.
16. Clarence King, "The Range," *Atlantic Monthly* 28, no. 159 (May 1871): 611–12.
17. King to Humphreys, 16 April 1867, Record Group 57–M622–3, National Archives.
18. King to Humphreys, 3 August 1867, Record Group 57–M622–3 (Line of March, p. 25), National Archives.
19. Samson, "High Rockies," p. 468.
20. A crayon lithograph copy of an O'Sullivan two-plate panorama, *Beaver Park Valley of Conejos River, Colorado*, was included as a double-page spread in Captain George Montague Wheeler, *Report Upon United States Geographical Surveys West of the One Hundredth Meridian* (Washington, D.C.: U.S. Government Printing Office, 1875–89), vol. 1, *Geographical Report* (1889), following p. 86 (hereafter cited as *Final Report*). The manifest of the collection of O'Sullivan photographs in the remarkable American Geographical Society Collection, now in the library of the University of Wisconsin, Milwaukee Campus, lists a multiple-plate panorama in albumen, but, unfortunately, the curator of the collection has been unable to locate what is assuredly the only surviving print of an O'Sullivan panorama. By matching contact prints with others made at the same time and location, I have identified twelve O'Sullivan panoramas at the National Archives. Others doubtless exist.
21. Samson, "High Rockies," p. 475.
22. Album now in possession of E. Marshall Pywell, Washington, D.C.
23. Richard Bartlett, *Great American Surveys* (1962, repr. ed. Norman: University of Oklahoma Press, 1980), p. 338.
24. King to Humphreys, 18 December 1871, Record Group 57–M622–3.
25. Wheeler to Humphreys, 7 September 1870, Letters Received by Corps of Engineers, Record Group 77–2047, National Archives.
26. Lieut. G. M. Wheeler, 15 May 1871, from Halleck Station, Nevada, Special Orders, Special Field Orders & Circulars, 1871–73, Record Group 77–368, National Archives.
27. Bartlett, *Great American Surveys*, p. 342.
28. G. K. Gilbert, 21 September 1871, Geological Survey Field Notebooks, Nevada and Arizona, 1871, Record Group 77–3375, National Archives.
29. Wheeler, *Final Report*, 1: 158.
30. Ibid., p. 159.
31. Gilbert, 25 September 1871, Record Group 77–3375, National Archives.
32. Wheeler to King, 22 March 1872, Record Group 57–M622–3, National Archives.
33. King to Humphreys, 15 May 1872, Record Group 57–M622–3, National Archives.
34. O'Sullivan to Wheeler, 11 November 1875, Letters Received, Record Group 77–2901, National Archives.
35. Wheeler to Humphreys, 17 November 1875, Letters Received, Record Group, 77–2901, National Archives.
36. Wheeler to O'Sullivan, 28 April 1878, Record Group 77–362, National Archives.
37. Treasury Department job application, 6 November 1880, Records of the Department of the Treasury, National Archives.

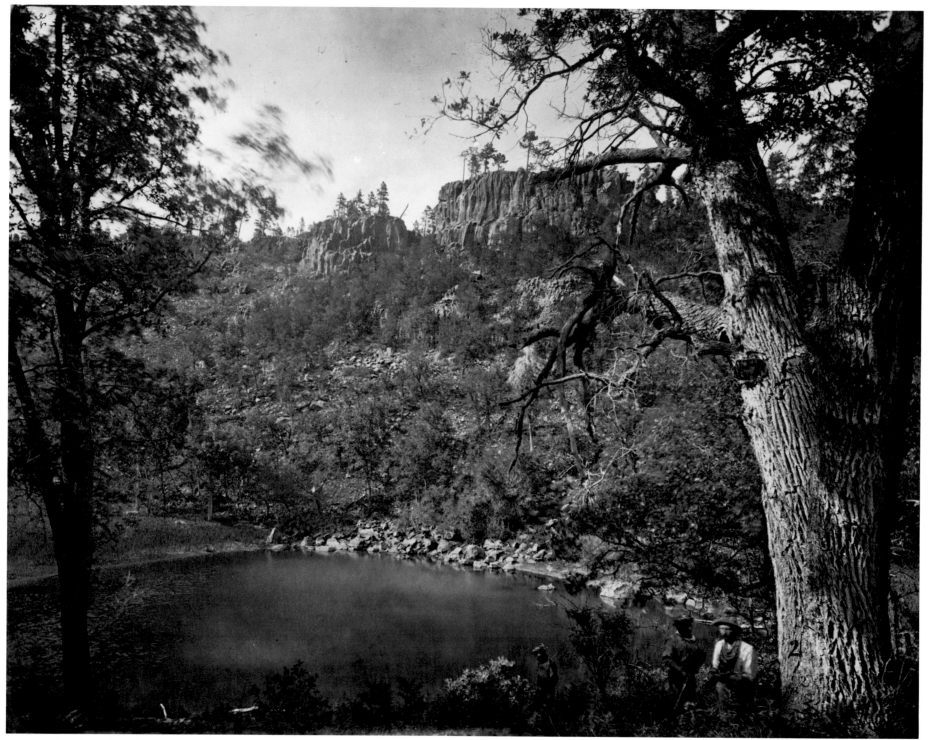

View on Apache Lake, Sierra Blanca Range, Arizona, 1873

II.

And I only am escaped alone to tell thee.

Job 1:15

IN 1874 WILLIAM HENRY JACKSON spent ten hours climbing the side of a mountain in Colorado to find a point of vantage from which he could photograph the Mount of the Holy Cross. When he reached the top, he assembled his outfit and photographed the mountain with the white cross of snow etched across its face. Later, back in Washington, Jackson examined the negative and discovered that the right arm of the cross was stunted and not quite straight. To fulfill what was manifestly nature's uncompleted design he took his retouching paint and his sable brush and reworked the negative. The search for the mountain with the cross, the ascent to photograph it, and the reworking of the negative typify the spirit with which Jackson and many other photographers approached the West. The notion of virgin nature as both literal and symbolic manifestation of God's beneficence to man, of a nature that offered the possibility of salvation and the possibility of a new beginning, was a powerful one in the period of the expeditions to the American West, and it found expression in the work of many landscape painters and photographers during the decades from 1850 through 1890. But it was not Timothy O'Sullivan's vision of the West.

In O'Sullivan's western photographs man is not embraced by nature but engulfed by it; he does not find salvation and forgiveness in it, but discovers it unforgiving. Unlike the work of landscape artists such as Albert Bierstadt and Thomas Moran, O'Sullivan's photographs do not portray na-

ture as majestic, breathtaking, or as somehow essentially humane. O'Sullivan's interior demands heroic labor and in return gives back very little; it is not usually the source of "pretty" pictures—few of them can be qualified by that adjective—it is the source of quiet, still, sometimes desperate pictures.

The men in charge of the expeditions hired O'Sullivan as an expressive picture maker, an illustrator of geological formations, scenic spots, and natural marvels. Although he had a knowledge of the fundamentals of geology, he was not a scientist, nor did he pretend to be one. His illustrations had a quasidocumentary use, but to classify them as "purely" scientific documents is to deny the avowed purposes of the men who took O'Sullivan west with them. The role of illustrator on the expeditions was filled by photographers, painters, sketchers, and topographic draftsmen. Their pictures appeared throughout the annual and final reports of the surveys and in various public exhibitions, side by side, with little or no thought given to the medium employed. The concern for joining the instructive to the artful, as well as judgments of the excellence or accuracy of the illustrations, was independent of specific considerations regarding media. Problems of formal coherence and the prevailing means of achieving it have a primary importance to a picture maker, even if the goal of illustration is assumed to be simply informative. The difference between a good illustration and a bad one involves both the purpose of the picture as well as traditional standards of picture making. A picture maker can adopt these standards or deny them, but he cannot avoid them. And when he denies them, he must make certain that the denial will not result in pictures that will confuse his audience.

With our modern myths of science and the near total domination of our thinking by cause-and-effect analysis, it is easy for us to think of photographs as inescapably bound to the factual, material, apictorial essence of nature. But in the nineteenth century the "facticity" of photographs was not established — especially among scientists.

In the *Progress Report* for the Wheeler expedition of 1872, the gifted geologist Grove Karl Gilbert discussed the value of photographic illustration on surveying explorations. His comments arise in the context of his discussion of a handmade lithographic copy of a photograph of "rain sculpture" in Nebo Park, Utah:

It is in the presentation of such subjects as these that the camera affords the greatest aid to the geologist: only with infinite pains could the draughtsmen give expression to the systematic heterogeneity of the material, and, at the same time, embody in the sketch the wonderfully convoluted surface, so suggestive of the folds of heavy drapery.

But to photography the complicated is as easy as the simple, the novel as the familiar. The negative once secured, the observer may at any time, and at his leisure, restudy the view, of which a hurried visit has given him but an impression: and more than this, he is enabled to publish its lesson, or its story, with the vividness that pertains to all graphic illustration, and with a guarantee of accuracy afforded only by the work of the sun.[1]

Gilbert's primary emphasis is on the *ease* with which illustrations can be obtained with photography, and, although he obviously cares a great deal about precision, he does not find that the "guarantee of accuracy afforded by the sun" provides any additional vividness or special photographic significance to the pictures. Indeed, Gilbert asked O'Sullivan on more than one occasion to "work up" a particular view for him and was, at least once, moved to write an esthetic evaluation of the results in his diary: "O'Sullivan took a sowpurite [so pur-i-te, i.e., 'pretty'] view of Loring cañon &c. for me."[2] But even the ability of photographs to reproduce with scientific accuracy was still open to analysis in the 1870s. Two paragraphs after Gilbert's comments in the *Progress Report*, George M. Wheeler added a few thoughts of his own about photography, which are representative of the nineteenth-century scientists' views on the new medium.

I will also state some of the practical uses which may result from the application of *the art of photography* as an auxiliary in our interior surveys.

It has been considered that the professional uses of photography, as an *adjunct* to a survey of this character, *are few, so far comparatively little good beyond that which is of general interest as expressive of the scenic features of specified areas*. The material gathered from its use apply only to the departments of geology and natural history.

In these departments, where, it is well understood we are obliged to leave the field of exact science, the special value that comes from a geological series of photographs results in the determination of a relative comprehension of the size and contour of the rock beds and of the general features of the topography. (italics added)[3]

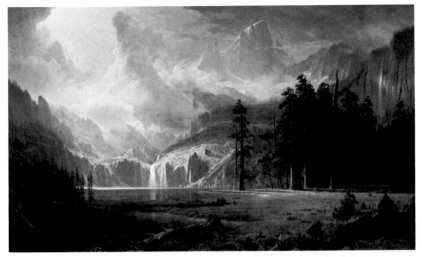

Mount Whitney, Grandeur of the Rockies, by Albert Bierstadt, 1875

The Chasm of the Colorado, by Thomas Moran, 1873–74

Wheeler had a thoroughly refined notion of science in mind when he claimed that photography's contribution was a "relative comprehension of . . . size and contour"—something that a handmade illustration can give as well. His is the modern scientist's conception in which precise measurement plays a central role. For Wheeler, photography could not be strictly scientific until, as he added a few paragraphs later, a method could be found to give numerical "value to the horizontal and vertical measurements upon a photographic picture."[4]

In fact, it is no more possible for a landscape photographer (even a "purely scientific" one) to make pictures without concern for what landscapes are supposed to look like than it is for an illustrator of a field book for the study of birds to make his pictures without a knowledge of what pictures of birds look like.

The give-and-take between the desire for informative illustrations "of general interest as expressive of the scenic features of specified areas" and purely esthetic concerns occurs frequently in the writings of many chiefs of expeditions, including William Henry Jackson's employer, Ferdinand Vandiveer Hayden. In the *Eighth Annual Report* (1874) of his group Hayden writes, "Especial attention has been paid, all the time, to make these views [photographs by Jackson] instructive as well as pleasing to the eye."[5] At times, a survey chief's frustration with photographs is purely an esthetic frustration. Wheeler notes in the first volume of his final report, while discussing an illustration,

Plate XI — This view (in colors) is introduced to illustrate, although but rudely, the beauty of the park-like valleys found almost indiscriminately along the flanks

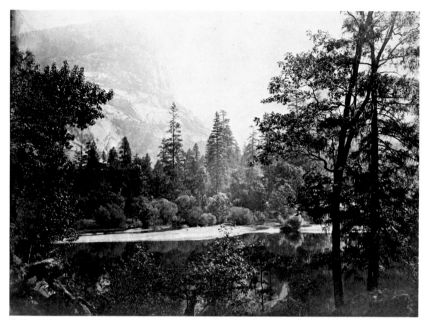

Lake Ah-wi-yah, Yosemite, 1861, by Carleton Watkins

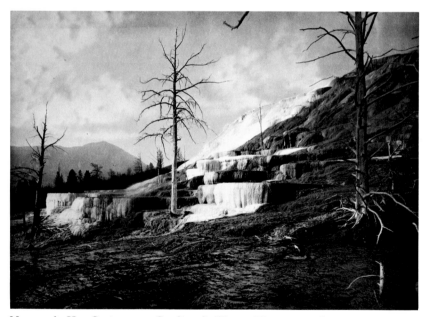

Mammoth Hot Springs on Gardiner's River, Wyoming, after 1880, by William Henry Jackson

of the Sierra Blanca Range of Eastern Arizona. It is a reproduction [a lithographic copy] of the only typical scene photographed by the late Mr. T. H. O'Sullivan. No picture can equal the original and no pen or language describe the rugged grandeur of the broken surrounding mesa and mountain or the gentle valley like glade finely grassed and interspersed with pine groves. . . . The coloring is by the hand of Mr. J. H. Morgan, following sketches and notes taken in the fields.[6]

Wheeler introduced the illustration in an attempt to show the "beauty" of the Sierra Blanca Range. A scientist, even a soldier-scientist, has a special interest in questions of formal elegance in the presentation of his findings. Producing a beautiful book or powerful illustration is not the exclusive province of self-conscious artists. Nonetheless, although Wheeler obviously believed that no picture maker, whether photographer or painter, and no writer could have equaled the original, he could find only one "typical" scene among the many photographs that O'Sullivan made in the Sierra Blancas. O'Sullivan was not a photographer who used easy formulae.

Just as questions of esthetic value had to be—and were—considered by photographers, so questions of accuracy had to be treated by painters. There was nothing inherently odd in the use of paintings to provide accurate, informative illustrations for the surveys. In 1872, when snow-blocked passes made photographic work in the Sierra Nevadas impossible, Clarence King wrote to General Humphreys: "In my general plan submitted last winter, I included a photographic representation of that region [Mount Humphreys in the Sierra Nevadas] and proposed to

employ Mr. Watkins at a liberal rate. Owing to the snow and the difficulty of reaching points, I deem it wise to give that up, and am the more willing as Mr. [Albert] Bierstadt the artist, has joined the party and will give me liberty to copy any or all of his studies."[7]

Thus, survey photographs were understood to be both documentary and expressive — documentary as illustrations that provided information about the detailed structure, relative size, and spatial relationships of the geological features of the explored regions, and expressive in that they were pictorially interesting, "pleasing to the eye," or in some sense esthetically noteworthy. This does not mean, however, that O'Sullivan self-consciously conceived of himself as an artist. As with a graceful bridge or a beautiful piece of pre-Columbian pottery, it is the quality of the work that allows us to qualify a maker of things as an artist and not the quality of the intention (assuming that there ever is something like "the" intention). If O'Sullivan did not think of himself in the same terms that Thomas Moran or Albert Bierstadt thought of themselves, he still had to consider pictorial integrity, coherence, the quality of light, and the range of tonal values.

It is popularly believed that a major reason the expedition leaders took O'Sullivan to the West was because they knew that they would need pictures to convince the responsible government agencies to fund further field work — in other words, that O'Sullivan's true role might simply have been "publicity photographer." Certainly, if the leader of an expedition wanted to use photographs as persuasive tools for the extrication of funds from Congress, he would have been well advised to produce "crowd pleasers." And the picture maker, in turn, would have had to decide just what would please the crowd. To answer that question would have required an understanding of conventionally accepted modes of landscape depiction, an approach that clashes with the allegedly disinterested and apictorial notion of documentary.

In fact, O'Sullivan's photographs were never used for raising funds. Clarence King's explorations were initially

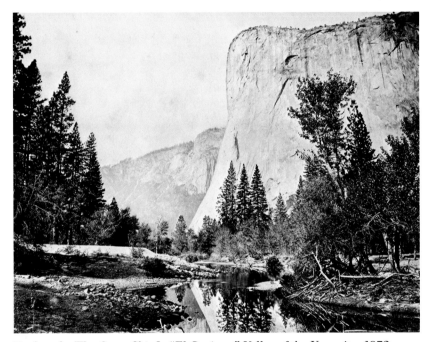

Tutokanula (The Great Chief), "El Capitan," Valley of the Yosemite, 1872, by Eadweard Muybridge

funded by Congress for three years, and he was safe from a year-to-year appropriations review. He did not find it necessary to scurry around making albums of views that would impress the War Department or the Congress with the value of his work. In fact, the record shows that General Humphreys had to plead with King to have sets of photographs printed and bound for deposit with the Library of

41

Congress. O'Sullivan's first prints from the winter of 1868–69 were circulated only among members of the staff. Humphreys's first request for prints for the Library of Congress was made in early 1870, and King took many months to fill it, much to Humphreys's displeasure. In the case of the Wheeler survey, its initial funding was for one year only, and, while O'Sullivan did print a set of the first sea-

Geyser pool, Ruby Valley, Nevada, 1868

son's photographs, they, too, were for internal use. The first prints intended for distribution to scientists and other interested parties were made only after the end of the second season of surveying, by which time Wheeler's continued appropriations for field work for a number of seasons to come were fully assured. It is unlikely that King and Wheeler, who were especially patient in producing prints from negatives made in the field, ever considered using photographs as tools to gain funding.

The artistic ideology that gave shape to much of western American landscape painting and photography between 1850 and 1890 depended heavily on a romantic conception of the ideality of nature and its transcendent significance. The West, the wilderness, and unspoiled nature came to represent in the minds of many artists and writers a place of salvation, where the benevolent handiwork of God could still be appreciated in its unspoiled majesty. Even today, some of this mythology survives in western films and stories and in the vocabulary of many westerners, who still refer to their land, without sarcasm and with an intended comparison to the East, as "God's Country."

The romantic mode of painting and photography stresses the "picturesque." In the picturesque mode of landscape painting, which can only be described here in simplified terms, nature is presented as rough, irregular, and asymmetrical. It is presented as inviting, hospitable, stimulating, but not to the point of irritation. Decayed natural (and manmade) objects are contrasted with a robust, flourishing nature. In picturesque landscape, the viewer is ordinarily given an easy entry into the picture. A path that leads to the foreground, or is in easy reach of the foreground, winds its way irregularly through the composition. A blasted tree may serve as a partial frame for the view. The picturesque mode aims to provide a varied experience of nature — of walking through a natural setting and slowly constructing the experience. When human figures populate picturesque landscapes they help to mediate between the viewer and the natural scene. Such figures are often bucolic, or otherwise appropriate types, who are engaged at work or, gaily or perhaps contemplatively, with their setting.

The picturesque mode originated in the work of British sentimentalist critics of the late eighteenth and early nineteenth centuries. These writers, especially Uvedale Price,[8]

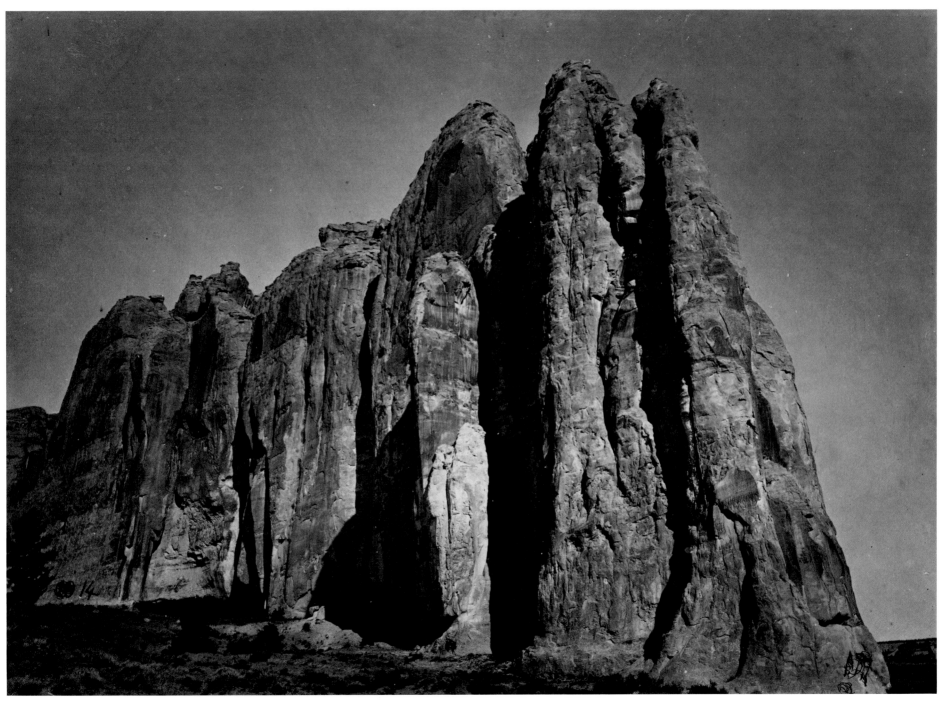

South side of Inscription Rock, New Mexico, 1873

43

William Gilpin,[9] and Payne Knight,[10] discussed the depiction of nature and the construction of gardens within a theoretical framework provided by Edmund Burke in his highly influential text *A Philosophical Enquiry into the Origin of Our Ideas of the Beautiful and the Sublime*. Burke in turn drew upon Greek critic Longinus's notions of the sublime. According to Burke, the "true standard of art" resides

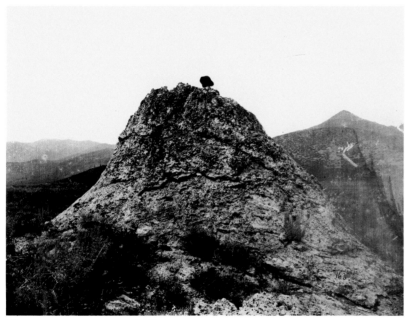

Hot springs cone, Provo Valley, Utah, 1869

in taste, and taste concerns the human passions. The two primary passions in art are terror, which is related to our desire for self-preservation, and the desire for human society, which is related, ultimately, to procreation. The sublime in nature or art finds its origins in the passion of terror, and the beautiful finds its origins in society. The sublime results from reaction to obscurity or darkness, to the power of vastly superior force, to privation (such as great silence or solitude), to vastness, infinity, uniformity, arduous labor,

and intense, blinding light. The feelings associated with the beautiful in nature were thought to be caused by small things — by delicacy, softness, regularity, and gradual variation. The beautiful and the sublime were understood to be polar opposites: an object could not be both beautiful and sublime.[11] But, as the later theorists emphasized, the picturesque could be joined to either the beautiful or the sublime. A beautiful face, for example, is characterized by softness, smoothness, and regularity, with very gradual variation from plane to plane. Such a face might well become insipid or monotonous unless "relieved" by picturesque features, hair that is tousled, irregular in its lines, and various in its hues and in the way it reflects light.[12]

Nineteenth-century landscape particularly stressed the joining of the picturesque to the sublime. A potentially terrifying landscape, one that depicts a vast canyon, for example, was muted with elements of the picturesque. The sky might be made to appear dark and majestic, potentially frightening, but the variations, even the playfulness, of the picturesque made the scene essentially inviting. It was the marriage of the sublime with the picturesque that characterized much of western American landscape painting and photography in the period between 1850 and 1890. It can be seen in the work of Moran, Bierstadt, and the illustrators who made sketches and paintings to illustrate expeditionary reports.

When critics of American landscape painting and photography speak of the "western sublime," they have the more modern notion of the picturesque-sublime in mind. The balance that had to be struck in American landscape if the West was to be represented as inviting was between the majesty and awe-inspiring aspects of nature (or, of God) and its inviting, humane, benign aspects. It had to be rep-

resented as a place of salvation and potential comfort. There had to be a secure place for man in nature. But O'Sullivan did not see the interior in these conventional terms. For him it was alien, immense, and difficult.

This vision stands out against the work of his contemporaries because it is a throwback to an esthetic mode that had declined before O'Sullivan was born. That mode is the *sublime* in the old sense of the term — the sublime as the awesome, the terrifying, the inhuman. It is a vision that is remarkably sympathetic with the views of the West of Clarence King and to an important extent, the views of George Montague Wheeler. In O'Sullivan's photographs, human forms often appear grotesque; grotesque geological forms are presented abruptly and are unsoftened by surrounding vistas. Large, monolithic structures often overwhelm the viewer with their size. Sky effects frequently add a gloomy aspect to the scene. At times, O'Sullivan denies the viewer a fixed position in the scene, often providing no foreground upon which the viewer may imaginatively stand and enter the picture to move through the represented space. Hard work — either the work actually depicted or the work implied in moving from the forward edge of the frame to a distant goal — is emphasized repeatedly. In particular, the motif of violent natural power, either seen (e.g., Shoshone Falls) or implied (e.g., volcanic domes or steam vents), underscores the threatening aspects of nature.

Isolation is perhaps the central theme in the photographs, often implied if not pictured directly. Often it is raised as an issue, when there is no apparent need to raise it at all. In a view of Ogden, Utah (page 55), an immense field stretches out below. As viewers, we are somehow standing above the field, although where we are standing is not indicated. There is a slim strip of the town in the mid-

to-background and a range of mountains far beyond. The sky is dark and brooding. The picture is completed, perhaps it is even achieved, by the placement of a figure, apparently in dress rather than work clothing, in what can only be called the foreground, though even this plane is far away. The picture is made from the interior looking toward the frontier, and the figure is caught between. From "strictly" documentary considerations, a human figure is not needed at all in the picture; any scale that might be required is given by the sagebrush. In a real sense the picture is about solitude, about one man contrasted to an immense,

Ruins in ancient pueblo, San Juan, Colorado, 1874

brooding nature. Again, in the well-known view of Sand Springs, Nevada (page 63) the themes of isolation, solitude, and silence are foremost. The presence of man is indicated by the wagon and the horses and the footprints in the sand that lead directly to the bottom edge of the frame. Man's marks in the sand are transient. Neither the foot-

prints nor the wagon traces can last. The path through the sand, formed by the presence of man, provides a way into the picture, but it is an evanescent path. Nothing of human

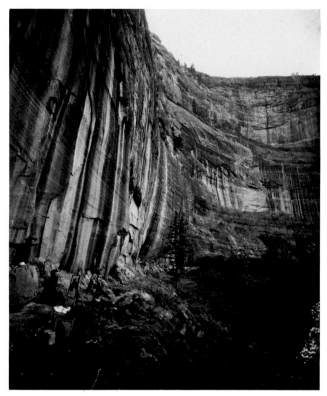

Artist A. H. Wyant sketches while O'Sullivan (extreme left) watches, Canyon de Chelly, New Mexico, 1873

importance can grow here, nothing animate can be sustained. The environment is sterile.

In some photographs, like the one on page 64, man is not only alone in the spare, unvegetated environment, he is obliterated by it. O'Sullivan made three views at this spot, one without figures, one in which the figure is barely visible, and this one, which was chosen for publication in the photographic album that accompanied the survey report. Certainly the figure suggests the size of the fissure, but it

gives expression to the unhappy relationship between the ghostlike figure and the nature that obliterates it. In the photograph on page 42 a man lies at the mouth of a grotesque vent in the ground. Although the negative includes the head of the man, O'Sullivan consistently cropped it out of the mounted picture. Again, the inclusion of a human figure may be justified as a technique for showing scale, but the mode of juxtaposition is weird in the nonpejorative sense. The nature displayed in these pictures seems to leach personality from those who come in contact with it. Another example of this odd juxtaposition of natural feature and human figure is found in the photograph on page 44. Here, the disembodied head of a man seems to grow out of a tufa mound that seems, itself, to grow out of the ground. O'Sullivan wanted to give a clear indication that the mound was hollow and placed the figure standing within it. The way his head emerges over the lip is both strange and mystifying.

Many opportunities for making picturesque views presented themselves to O'Sullivan, but he resisted the temptation to make inviting pictures. Picturesque landscapes favored ruined buildings. The photograph on page 45 depicts a ruined stone house, but O'Sullivan placed it directly in the center of the frame. Gestures to indicate human scale, while successful, make the house appear even stranger. A figure in the shade, a long ruler, and a jacket hung on a decaying wall have far more in common with surreal painting than they do with nineteenth-century landscape depiction. O'Sullivan responded much differently to situations than photographers who used picturesque formulae.

Even when O'Sullivan's response came closest to prevailing norms, he seems to have been unable to suppress the desire to add something odd or potentially hazardous. Two

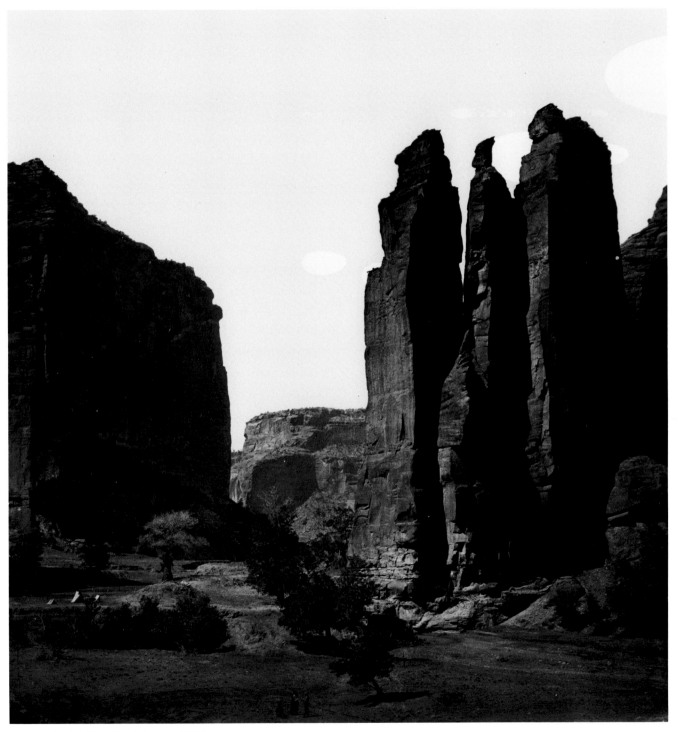

Canyon de Chelly, New Mexico, 1873

47

photographs of Canyon de Chelly (pages 47, 93) are made roughly from the same standpoint, but the tilt of the camera in the horizontal view (the one chosen for official publication) gives the impression that the large columns to the right are angled menacingly toward the insignificant tents

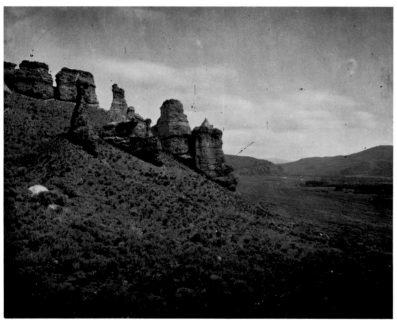

Witches Rocks, Echo, Utah, 1869

that stand to the left of bottom center. The vertical view places the columns in nearly perpendicular relation to the ground. At times, O'Sullivan appears to have had little respect for "the facts" of geology when it came to composing a picture. In two photographs of the same tertiary rock formations (pages 48, 71), O'Sullivan sharply angled the camera in the close-up view so that the lines of the rocks establish an entirely different relationship to the horizontal than they do in the more distant picture.

O'Sullivan's photographs reveal the nature of the interior.

If that nature is virgin and unspoiled, it is also menacing and beyond human scale. If its transcendent nature symbolizes the work of God, that work is neither inviting nor hospitable. The God who made this nature does not offer comfort, and his design is inimical to the well-being of man. If it is God who is indicated by O'Sullivan's photographs, it is not the God of the New Testament, it is the awesome God, beyond human understanding, of the Old.

O'Sullivan's photographs share the spirit of Clarence King's geology and theology. This is not to suggest that King influenced him, or that O'Sullivan worked consciously (or unconsciously, for that matter) to illustrate King's modified catastrophist views of geology. Assertions concerning influence are notoriously treacherous to prove, even when evidence like letters, diaries, and other documents apparently confirm them. In the case of O'Sullivan and King, even such evidence is lacking. Yet a sympathetic resonance connects King's beliefs about the interior to O'Sullivan's photographs.

In late June 1877 King delivered the graduation address at his Alma Mater, the Sheffield Scientific School at Yale University. He spoke of his geology and his theology.

The earliest geological induction of primeval man is the doctrine of terrestrial catastrophe. The ancient belief has its roots in the actual experience of man, who himself has been witness of certain terrible and destructive exhibitions of sudden, unusual telluric energy. Here in America, our own species has seen the vast, massive eruptions of Pliocene basalt, the destructive invasion of northern lands by the slow marching ice of the glacial period, has struggled with the hardly

conceivable floods which marked the recession of the frozen age, has felt solid earth shudder beneath its feet and the very continent change its configuration. . . .

When complete evidence of the antiquity of man in California and the catastrophes he has survived come to be generally understood, there will cease to be any wonder that a theory of the destructive in nature is an early, deeply rooted archaic belief, most powerful in its effect on the imagination. Catastrophe, speaking historically, is both an awful memory of mankind and a very early piece of scientific induction. . . .

Not very far in the future it may be seen that the evolution of the environment has been the major cause of the evolution of life; that a mere Malthusian struggle was not the author and finisher of evolution; but that He who brought to bear that mysterious energy we call life upon primeval matter bestowed at the same time a power of development by change, arranging that the interaction of energy and matter which make the environment should from time to time, burst in upon the higher current of life and sweep it onward and upward to ever higher and better manifestations. Moments of great catastrophe, thus translated into the language of life, become moments of creation, when out of plastic organisms something newer and nobler is called into being.[13]

King's God is a terrible God. The history of the earth is one of God-induced catastrophe relieved by periods in which God allows his creation to work itself out, to reach a point of development from which it could not proceed without further intervention in the form of terrifying, life-obliterating catastrophes. The area of the Great Basin between the eastern slope of the Sierra Nevadas and the western slope of the Rocky Mountains is a vast wilderness that bears the unhealed wounds and the scars of cataclysms. King claimed that he had studied a one-hundred-twenty-five-thousand-feet-thick cross section of the Cordilleras — a twenty-five-mile-deep slice through time — that showed the marks of repeated catastrophes. It is as if he had walked through a natural catacomb in which the calcified remains of early life and the bones of long-gone species gave witness to the magnificence and power of God.

O'Sullivan's photographs bear witness to a similar vision. As Gardner maintained, his photographs of the Civil War affirm the sacredness of certain places. So, too, do his photographs of the interior. The sacredness of the war found its origin in the righteousness of the cause of the Union, but the sacredness of the interior derived directly from the apparently chaotic impression of God's design. O'Sullivan's response to the American frontier was not to "prettify" it, but to show it as breathtaking — the proper response to the sublime. Many of the photographs outreach the esthetic classifications of their day because they verge upon being anesthetic — they stun and they numb.

In September 1868 O'Sullivan with King and a small detachment of soldiers from the surveying party journeyed from Utah to Idaho. King described the journey and its destination, Shoshone Falls, for Bret Harte's *Overland Monthly*. The group crossed the Goose Creek Mountains in northern Utah and descended to Snake Plain. King wrote,

A gray, opaque haze hung close to the ground, and shut out the distance. The monotony of sage-desert was

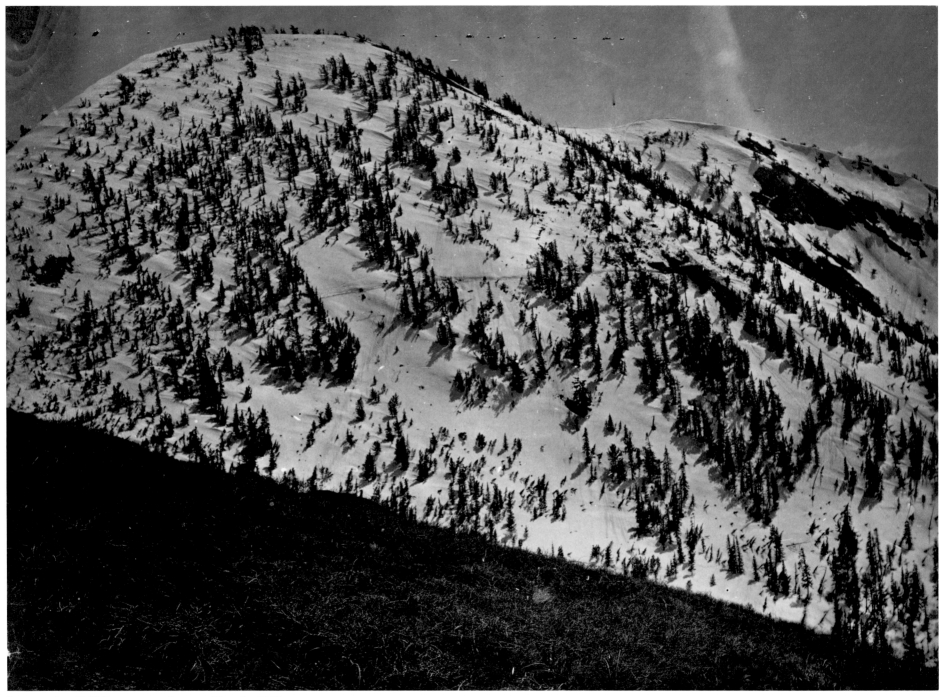

Snow peaks, Bull Run mining district, Nevada, 1871

overpowering. We would have given anything for a good outlook; but for three days the mists continued. . . .

A few miles in front the smooth surface of the plain was broken by a ragged, zigzag line of black, which marked the edge of the farther wall of the Snake Cañon. A dull, throbbing sound greeted us. Its pulsations were deep, and seemed to proceed from the ground beneath our feet. . . . Dead barrenness is the whole sentiment of the scene. The mere suggestion of trees clinging here and there along the walls serves rather to heighten than relieve the forbidding gloom of the place. Nor does the flashing whiteness, where the river tears itself among the rocky islands, or rolls in spray down the cliff, brighten the aspect. In contrast with the brilliancy, the rocks seem darker and more wild. . . . At the very brink of the fall a few twisted evergreens cling with their roots to the rock, and lean over the abyss of foam with something of that air of fatal fascination which is apt to take possession of men.

The Yosemite is a grace. It is an adornment. It is like a ray of light on the solid front of the precipice. No sheltering pine or mountain distance of uppiled Sierras guard the approach to the Shoshone. You ride upon a waste—the pale earth stretched in desolation. Suddenly, you stand upon a brink. As if the earth has yawned, black walls flank the abyss. Deep in the bed a great river fights its way through the labyrinth of blackened ruins, and plunges in foaming whiteness over a cliff of lava. You turn from the brink as from a frightful glimpse of the Inferno, and when you have gone a mile the earth seems to have closed again. Every trace of the *cañon* has vanished, and the stillness of the desert reigns.[14]

Throughout his years in the interior, O'Sullivan always worked as part of a group, sometimes with King or Wheeler, more often with a side party. In November 1874, for the first and only time, he worked alone. He traveled to the Snake River and photographed Shoshone Falls. These were to be the last photographs he made in the interior. He stood by the brink of "the Inferno" that was made of rushing water and with potentially fatal fascination made photographs of what he alone saw.

1. Lieutenant George M. Wheeler, *Progress Report Upon Geographical and Geological Explorations and Surveys West of the 100th Meridian in 1872* (Washington, D.C.: U.S. Government Printing Office, 1874), p. 11.
2. Gilbert, 7 September 1871, Record Group 77–3374, National Archives.
3. Wheeler, *Progress Report*, p. 11.
4. Ibid., p. 12.
5. Ferdinand Vandiveer Hayden, *Eighth Annual Report for the Field Season of 1874* (Washington, D.C.: U.S. Government Printing Office, 1874), p. 11.
6. Wheeler, *Final Report*, 1:76.
7. King to Humphreys, 14 August 1872, Record Group 57–M622–3, National Archives.
8. Uvedale Price, *Essay on the Picturesque* (London, 1794).
9. William Gilpin, *Three Essays on Picturesque Beauty* (London, 1792).
10. R. Payne Knight, *Analytical Inquiry into the Principles of Taste*, 2d ed. (London, 1805).
11. Edmund Burke, *A Philosophical Enquiry into the Origin of Our Ideas of the Beautiful and the Sublime* (repr. ed., Notre Dame: University of Notre Dame Press, 1968).
12. Cf. Price, *Essay on the Picturesque*, chaps. III–IV, and Burke, *A Philosophical Enquiry*, pt. I, secs. I–XIV; pt. II, secs. I–XVIII.
13. Clarence King, "Catastrophism and Evolution," *The American Naturalist* 11, no. 8 (August 1877): 449–70.
14. Clarence King, "The Falls of the Shoshone," *The Overland Monthly* 5, no. 4 (October 1870): 379–85.

In spite of any scientific labor or presence of fatigue, the lifeless region, with its savage elements of sky, ice, and rock, grasps one's nature, and, whether he will or no, compels it into a stern, strong accord. Then, as you come again into softer air, and enter the comforting presence of trees, and feel the grass under your feet, one fetter after another seems to unbind from your soul, leaving it free, joyous, grateful!

Clarence King, *Mountaineering in the Sierra Nevada*

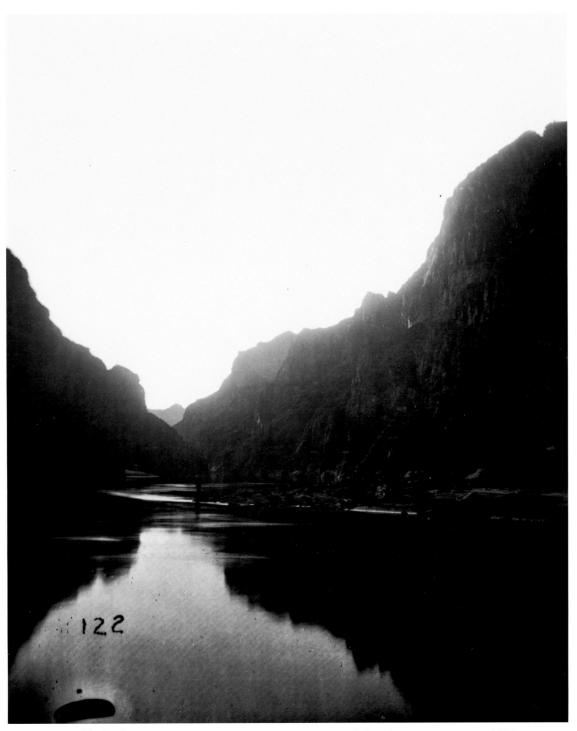

View across Black Canyon, the grand walls in perspective, Colorado River, Arizona, 1871

Longitude Hill, Ruby Valley, Nevada, 1868

Ogden, Utah, 1874

Pamranaset Lake district, Nevada, 1871

Mining area, Nevada, 1871

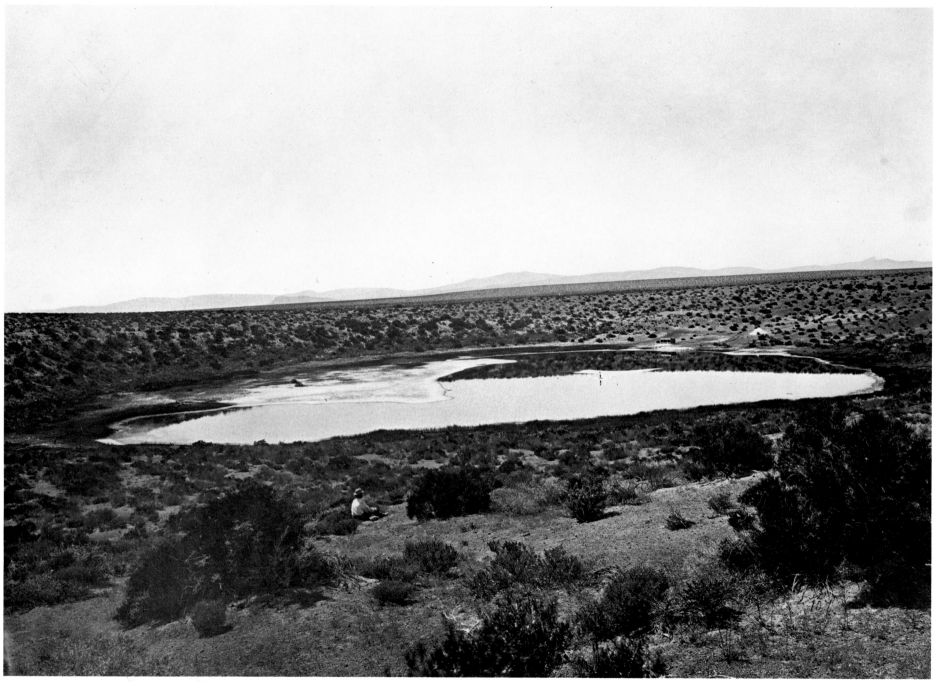

Carbonate of soda lake near Ragtown, Carson Desert, Nevada, 1867

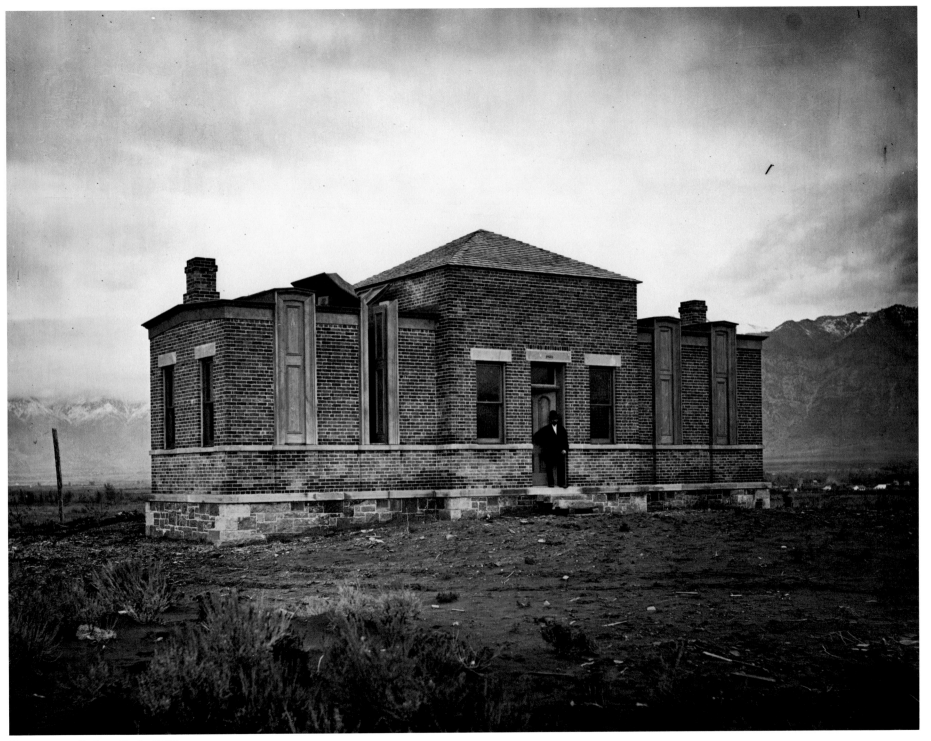

Observatory, Ogden, Utah, 1874

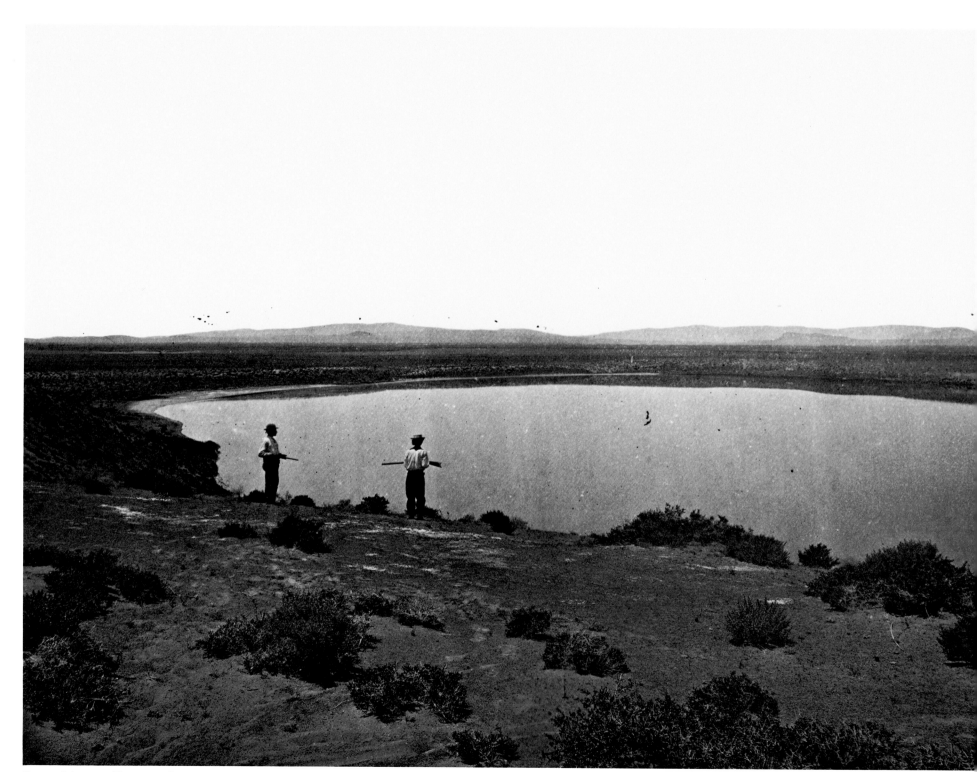

Desert lake near Ragtown, Carson Desert, Nevada, 1867

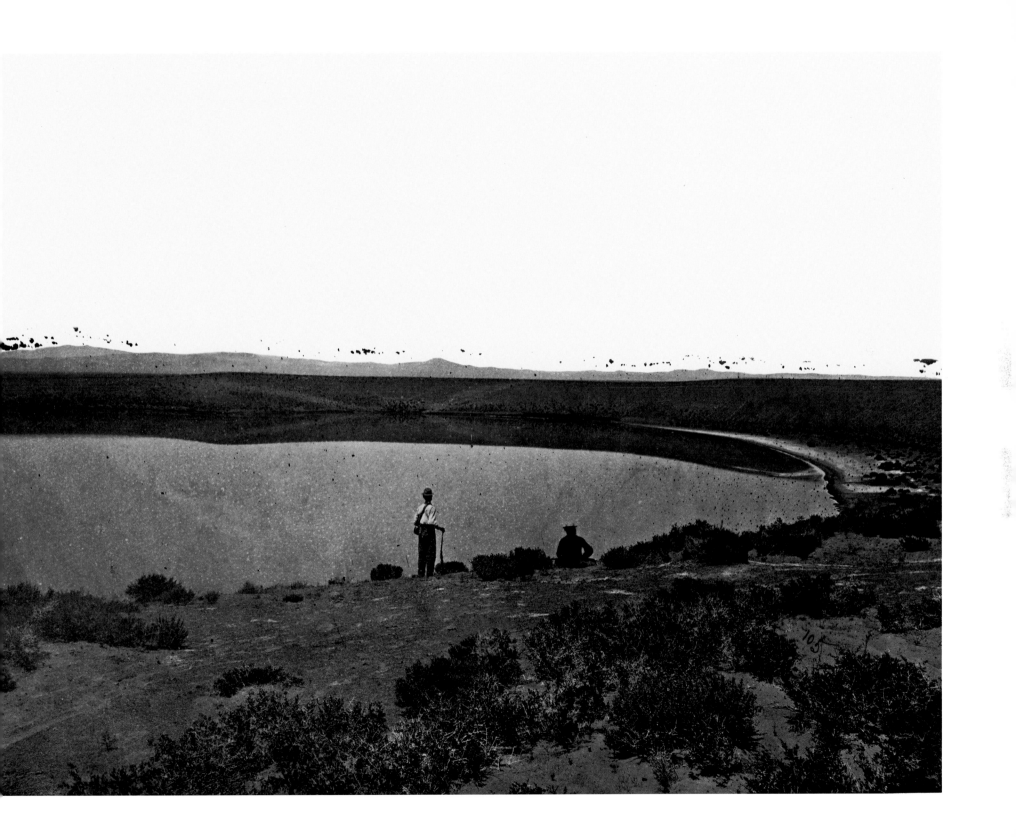

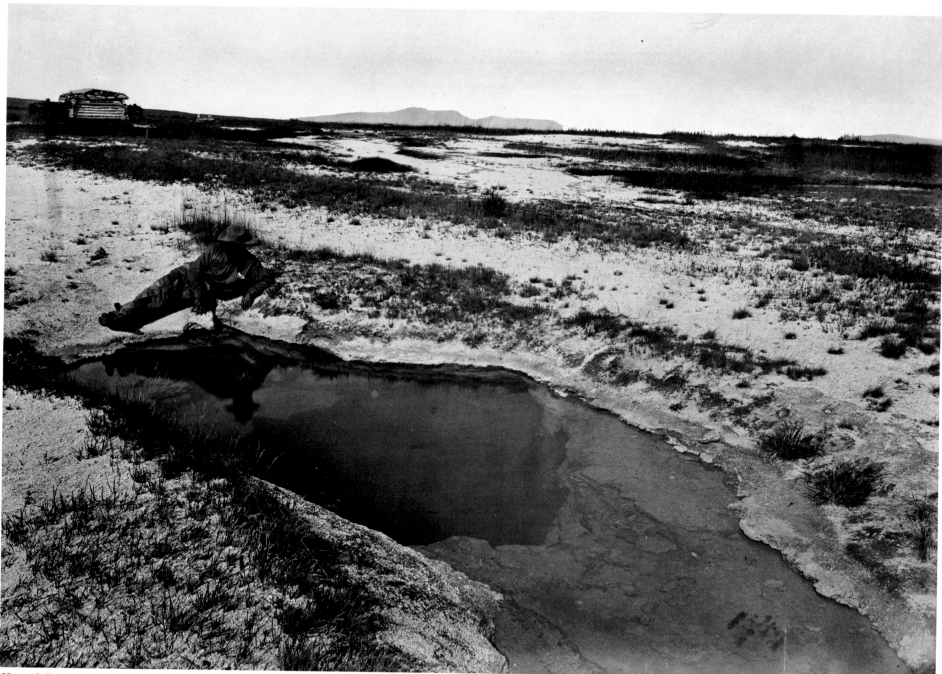

Hot sulphur spring, Ruby Valley, Nevada, 1868

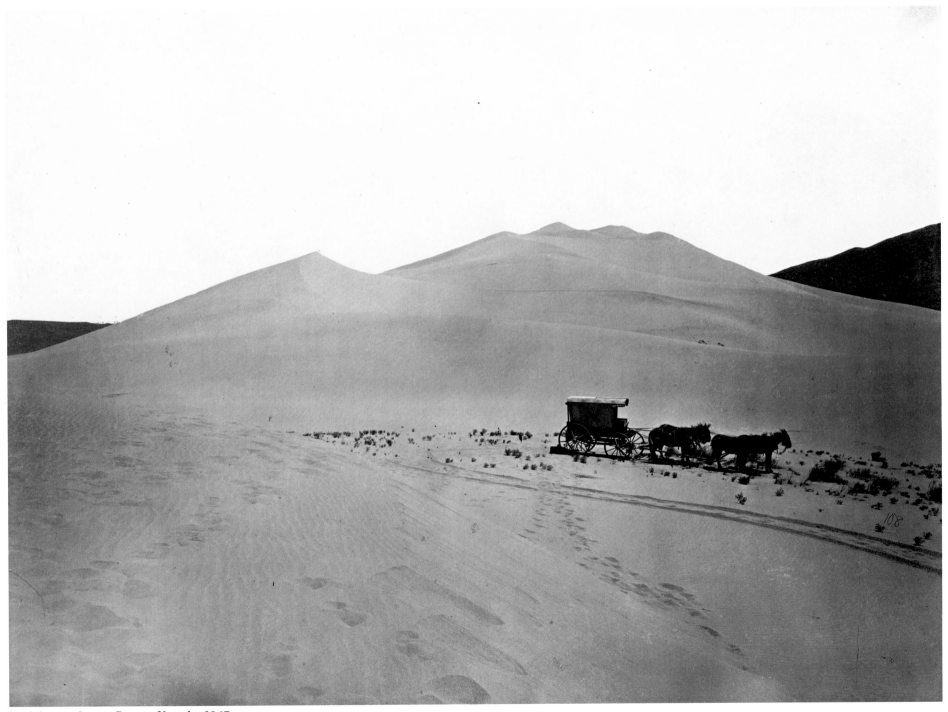

Sand dunes, Carson Desert, Nevada, 1867

Fissure vent of Steamboat Springs, Nevada, 1867

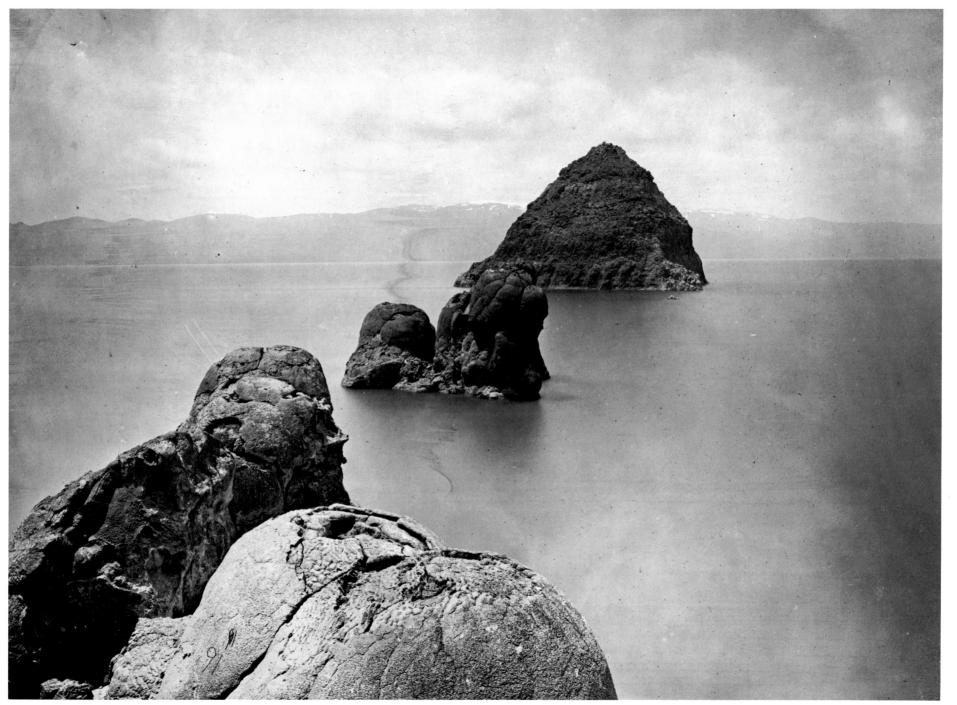

Tufa domes, Pyramid Lake, Nevada, 1867

A few miles in front the smooth surface of the plain was broken by a ragged zigzag line of black A dull throbbing sound greeted us. Its pulsations were deep, and seemed to proceed from the ground beneath our feet Dead barrenness is the whole sentiment of the scene. The mere suggestion of trees clinging here and there along the walls serves rather to heighten than relieve the forbidding gloom of the place. Clarence King, "The Falls of the Shoshone"

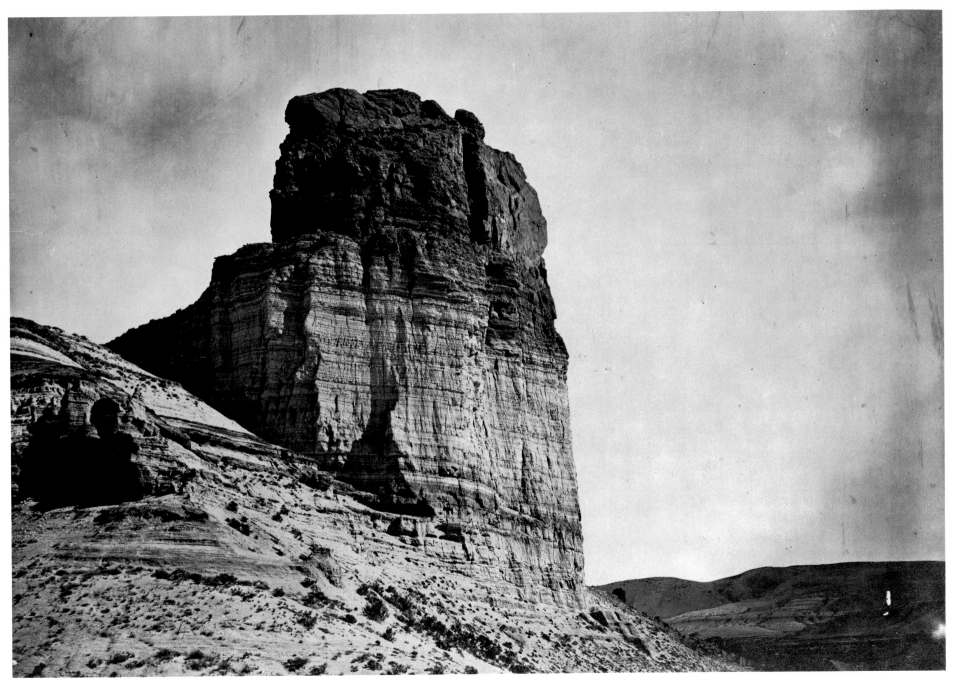

Tertiary bluffs near Green River City, Wyoming, 1872

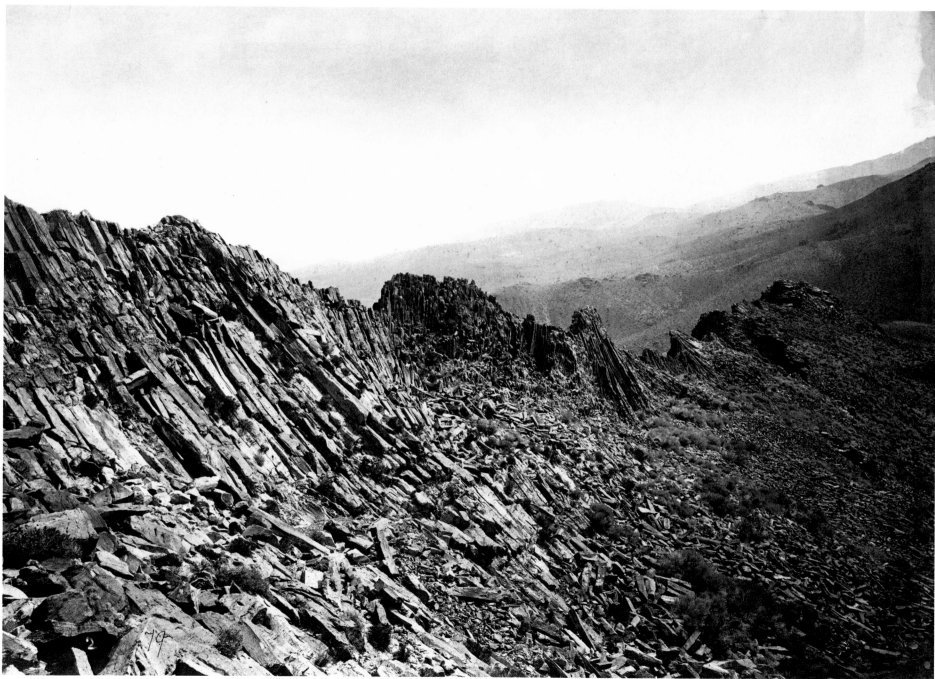

Ridge of columnar trachyte, Nevada, 1867

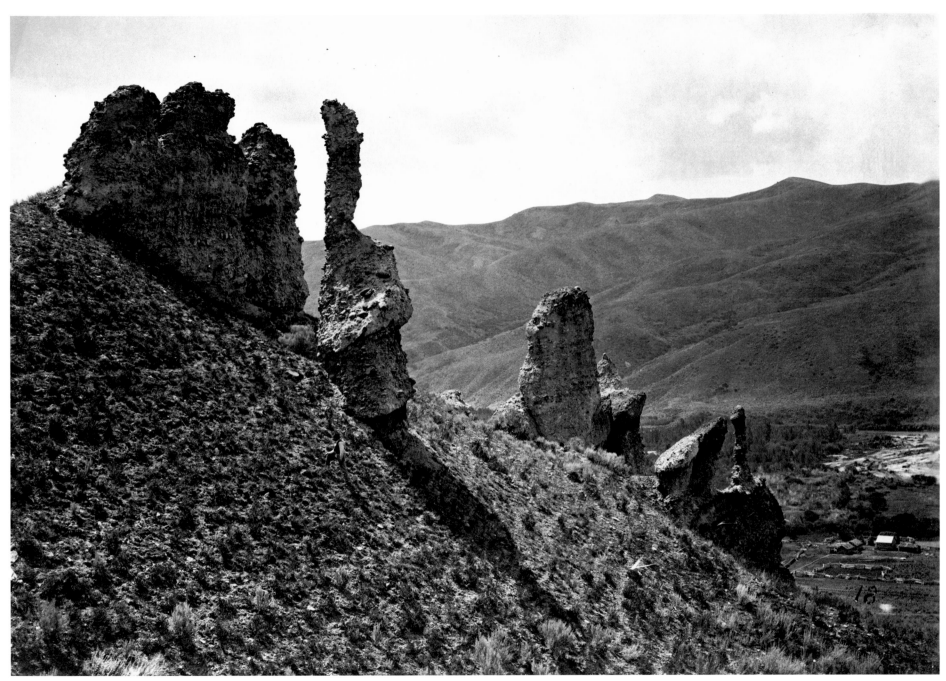

Tertiary conglomerates, Weber Valley, Utah, 1869

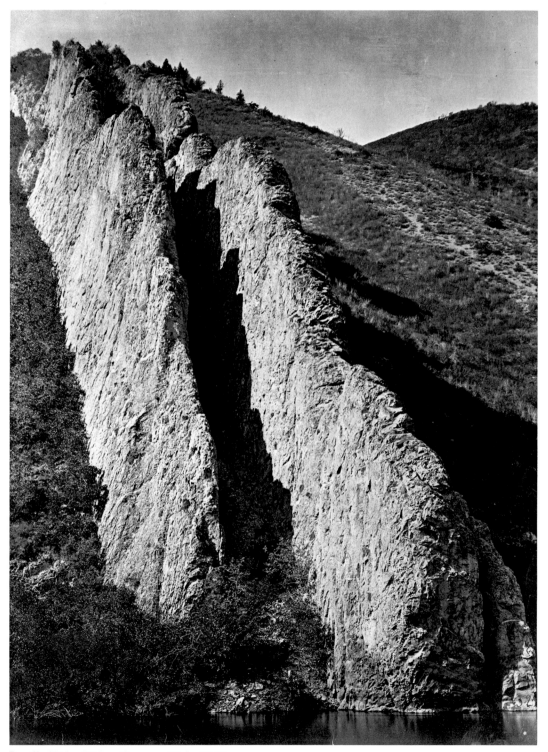

Devil's Slide, Weber Canyon, Utah, 1869

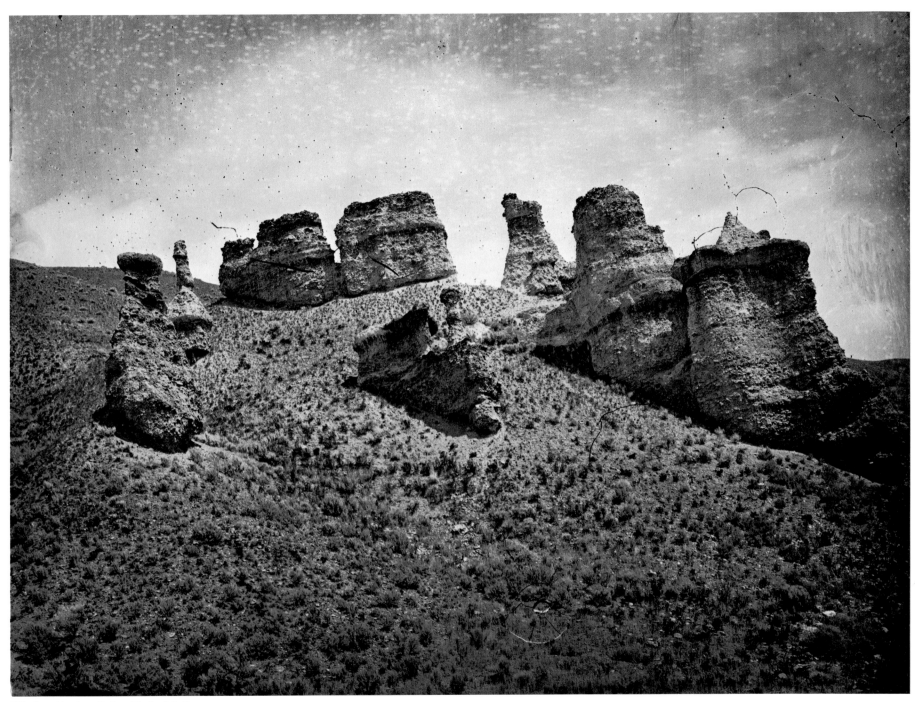

Witches Rocks, Echo, Utah, 1869

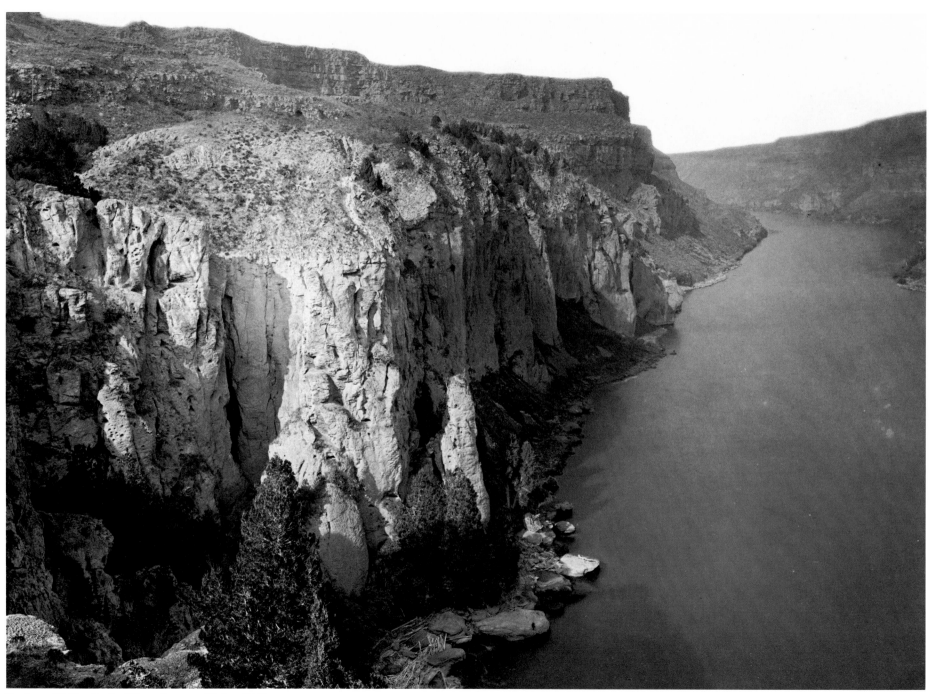

Trachyte Walls, Snake River Canyon, Idaho, 1868

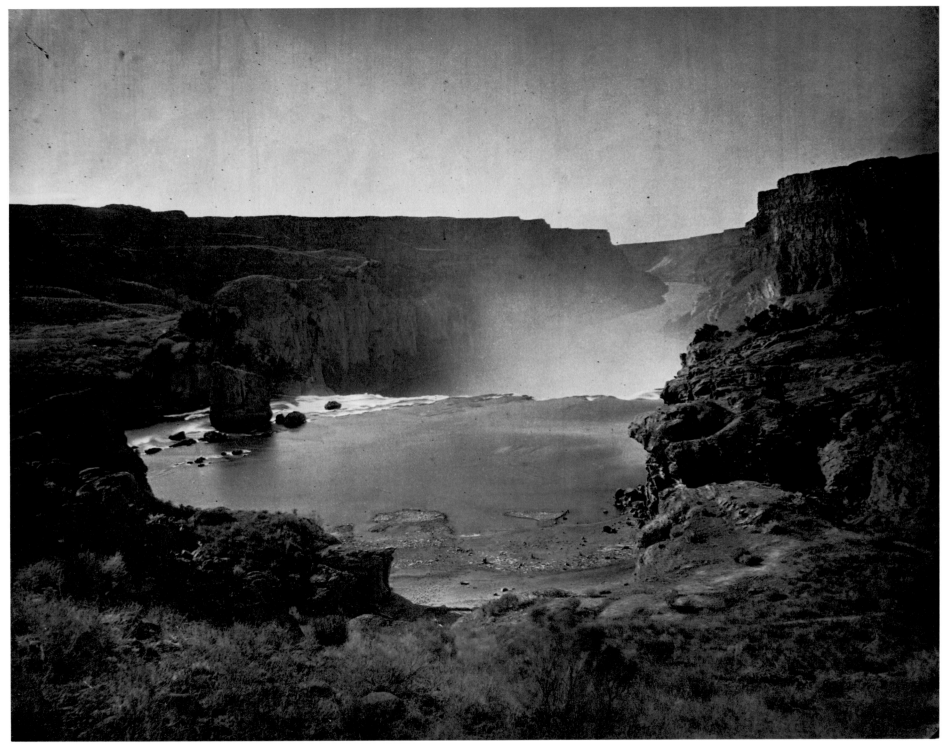

Shoshone Falls, Snake River, Idaho, 1874

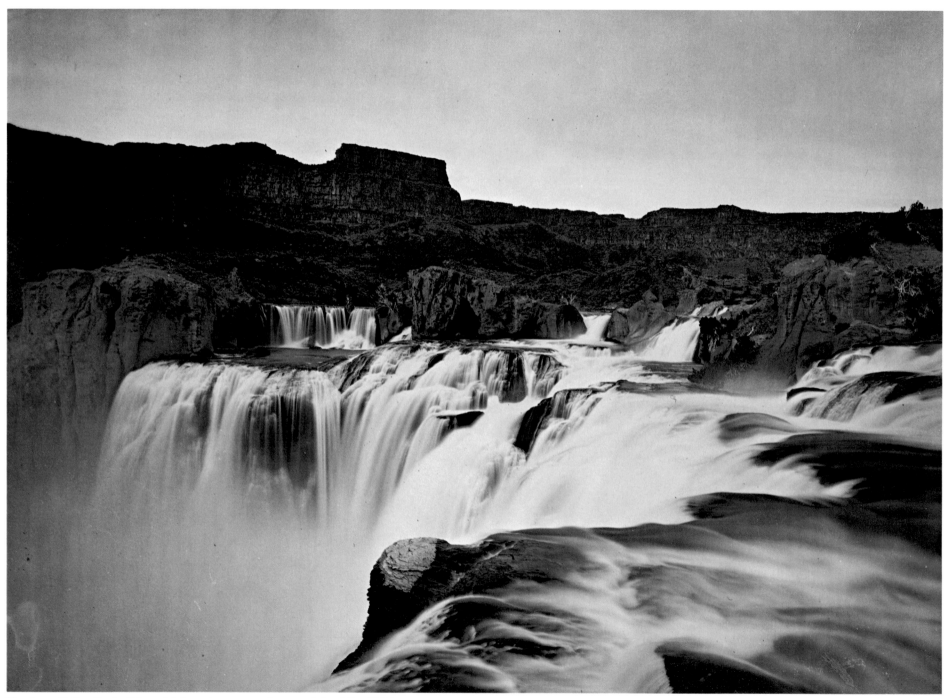

Shoshone Falls, Snake River, Idaho, view across the top of the falls, 1874

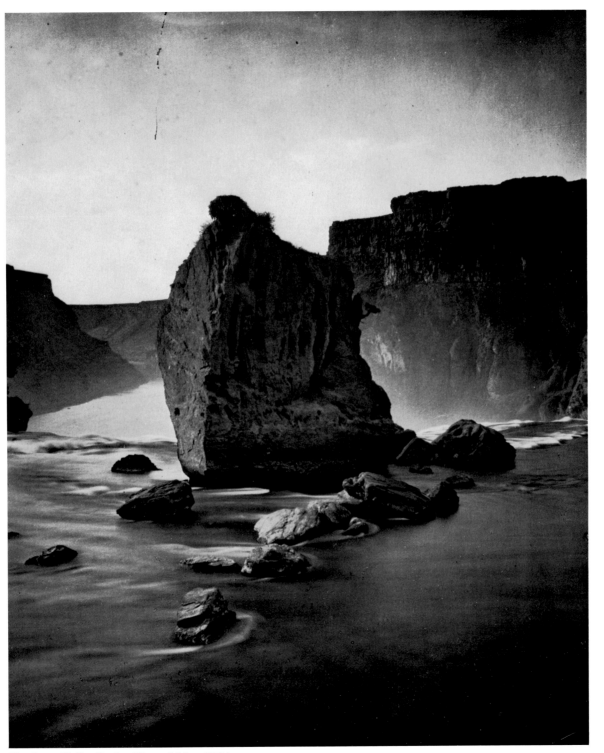

Shoshone Falls, Snake River, Idaho, 1874

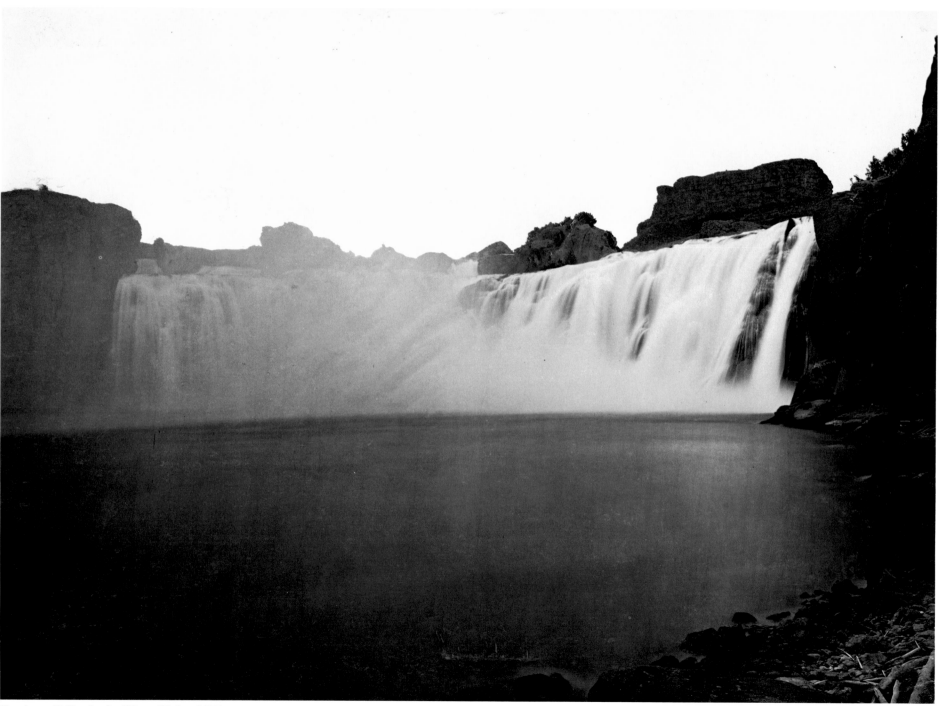

Shoshone Falls, Snake River, Idaho, 1874

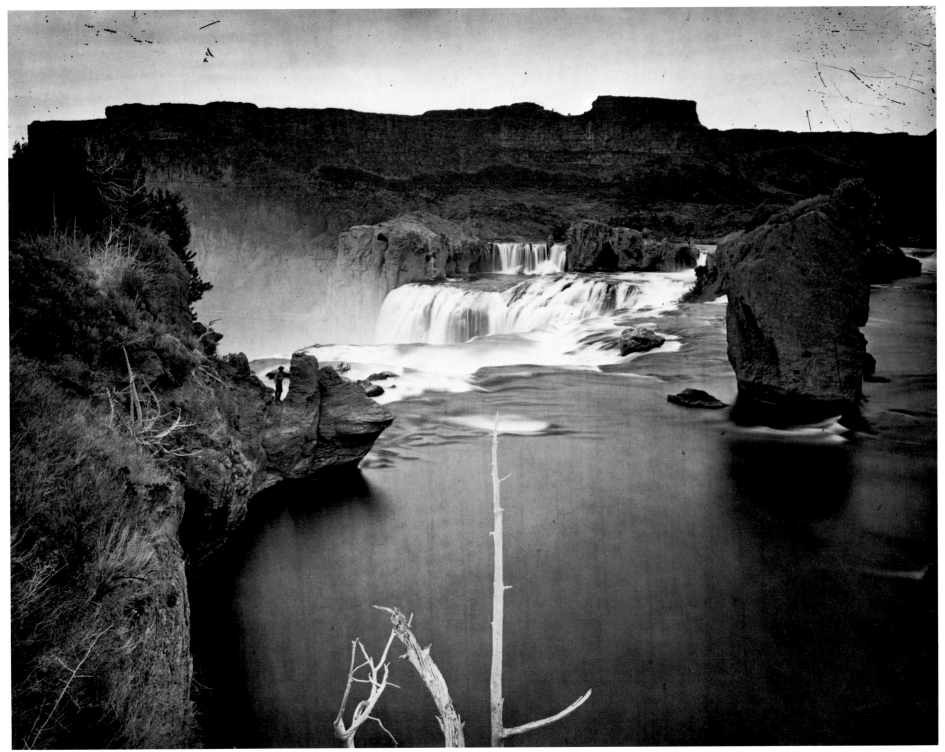

Shoshone Falls, Snake River, Idaho, 1868

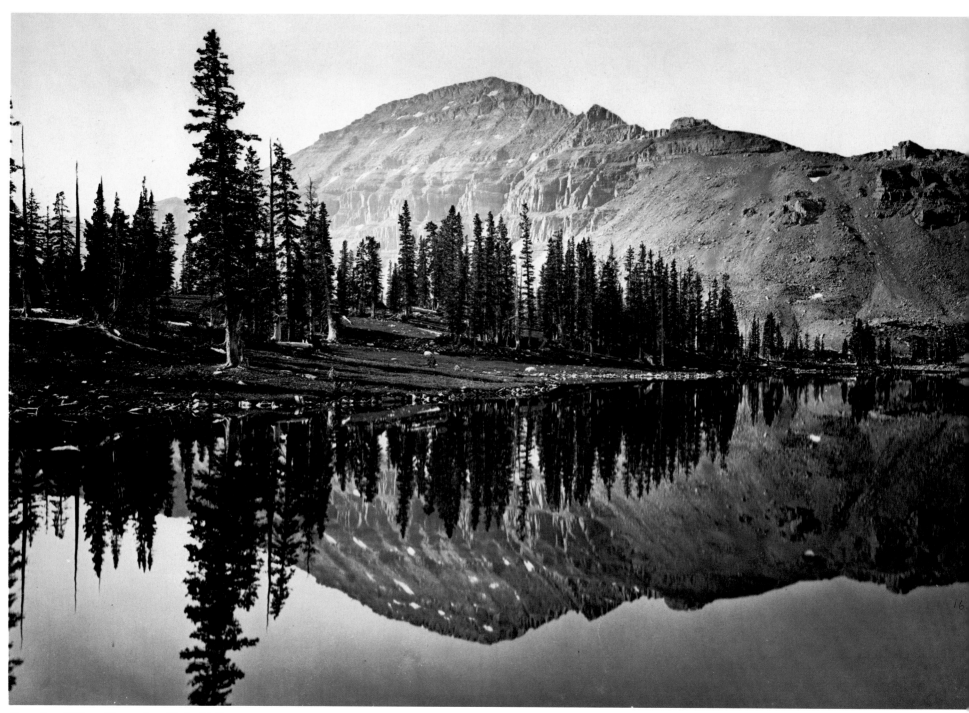

Summits of Uinta Mountains, Utah, 1869

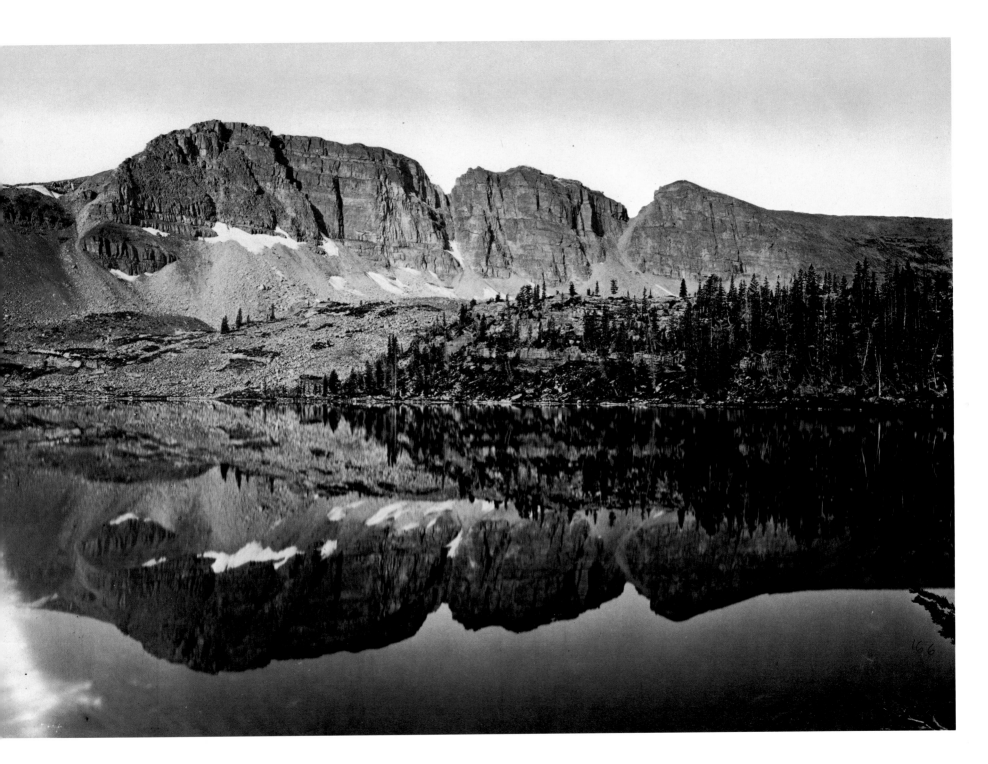

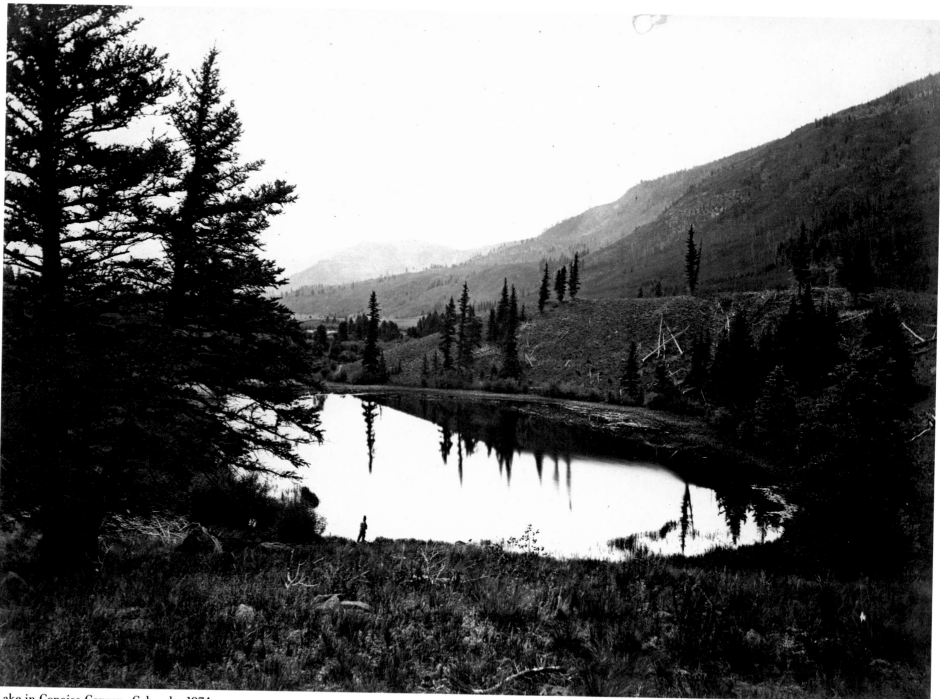

Lake in Conejos Canyon, Colorado, 1874

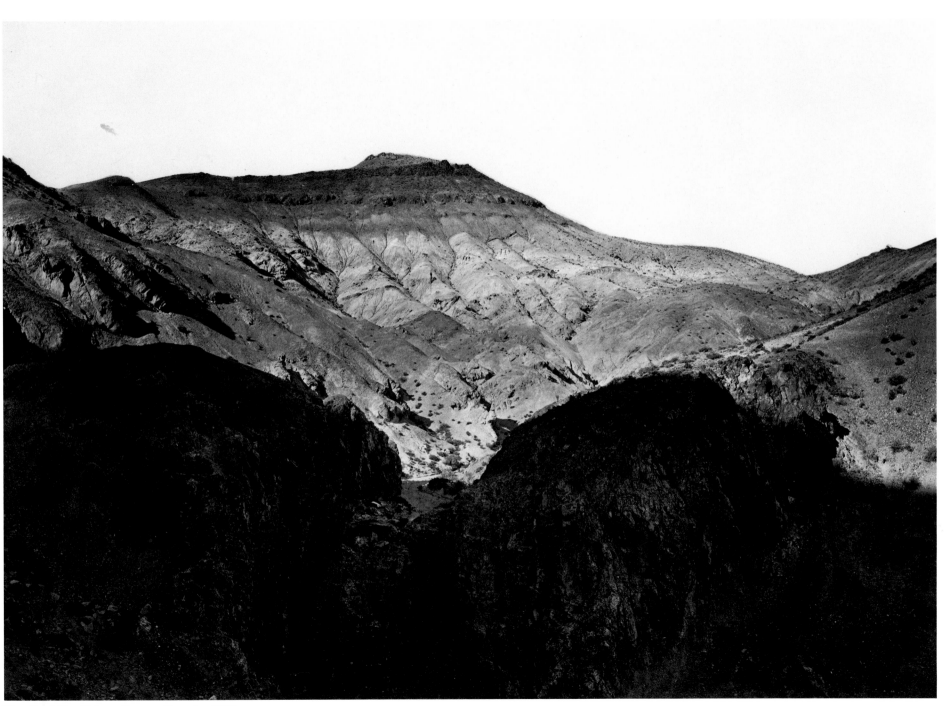

Rhyolite hills, Pahute Range, Nevada, 1867

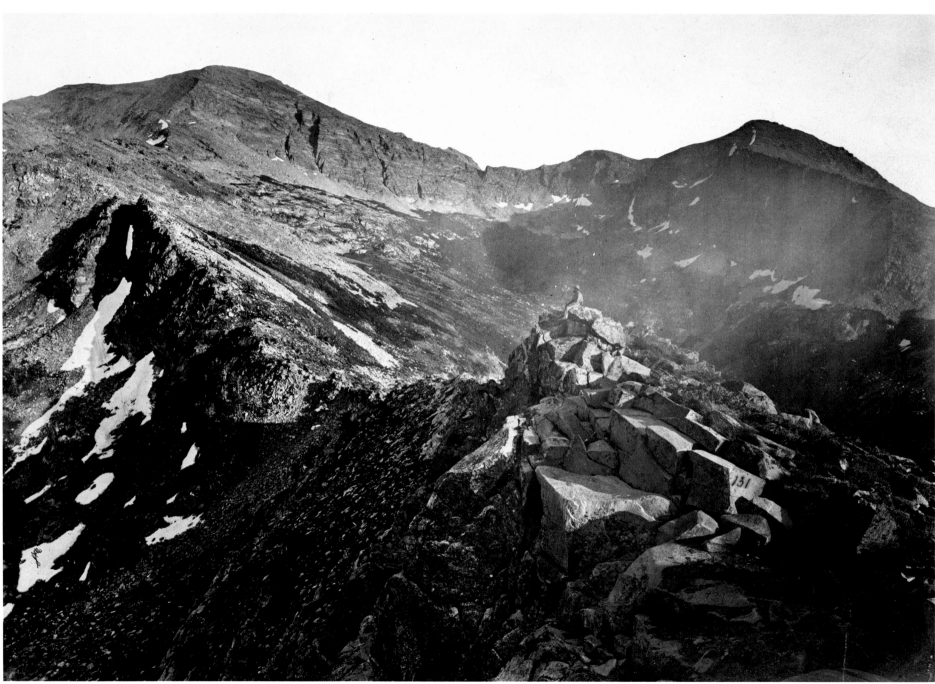

Clover Peak, East Humboldt Mountains, Nevada, 1868

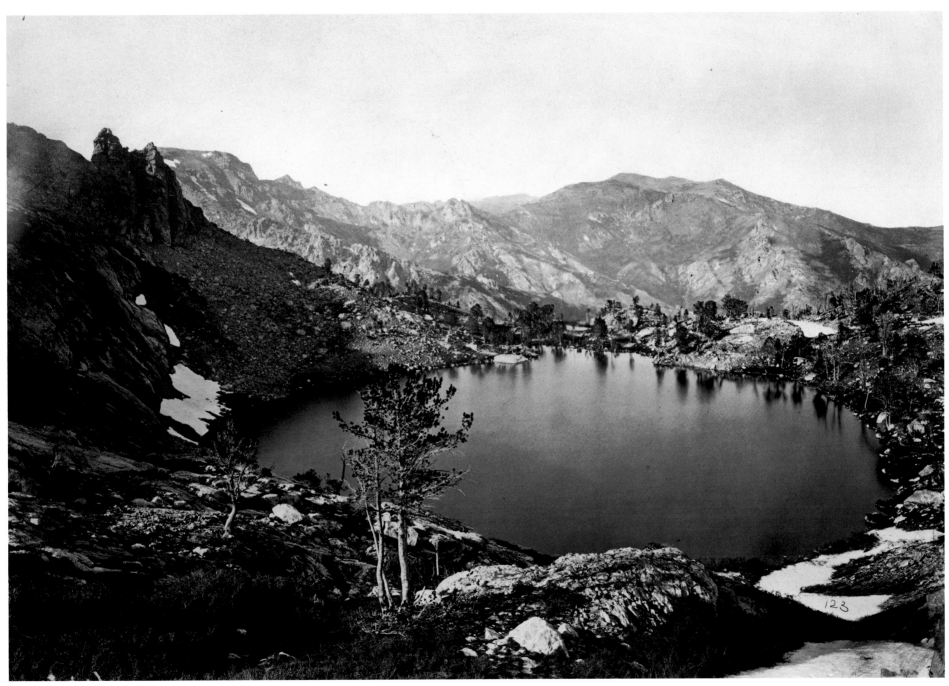

Lake Marian, summits of East Humboldt Mountains, Nevada, 1868

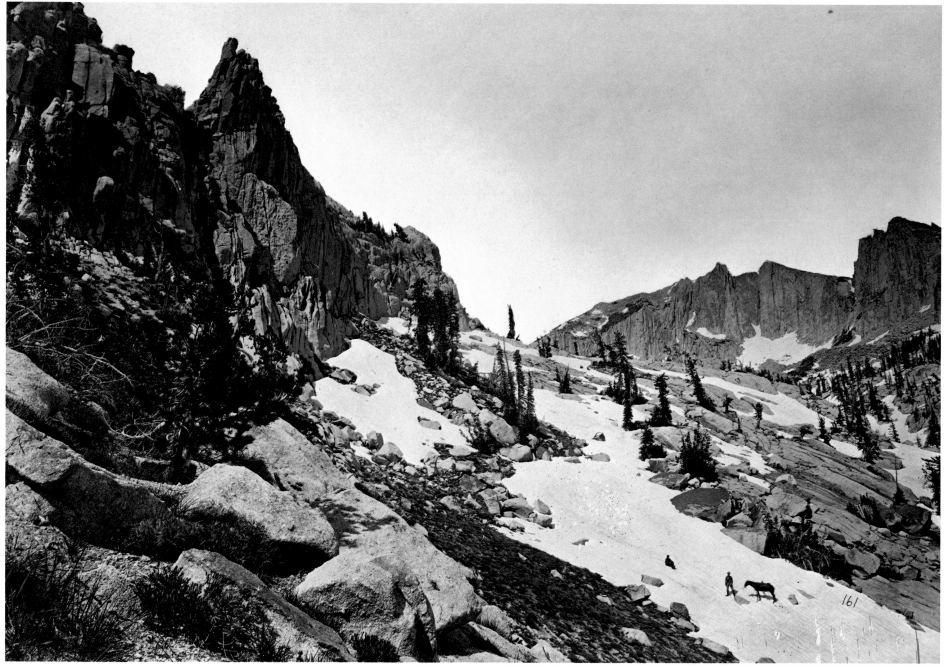

Wasatch Mountains, Lone Peak summit, Utah, 1869

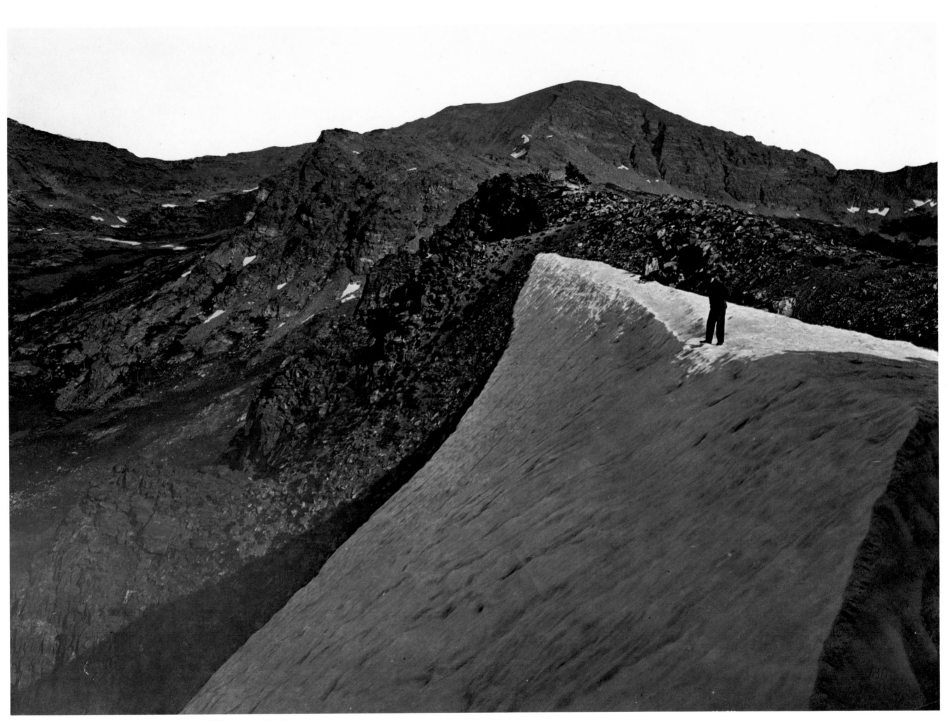

Summit of East Humboldt Mountains, Nevada, 1868

I was delighted to ride thus alone, and expose myself, as one uncovers a sensitized photographic plate, to be influenced; for this is a respite from scientific work, when through months you hold yourself accountable for seeing everything, for analyzing, for instituting perpetual comparison, and as it were sharing in the administering of the physical world. No tongue can tell the relief to simply withdraw scientific observation and let Nature impress you with all her mystery and glory, with those vague indescribable emotions which tremble between wonder and sympathy.

Clarence King, *Mountaineering in the Sierra Nevada*

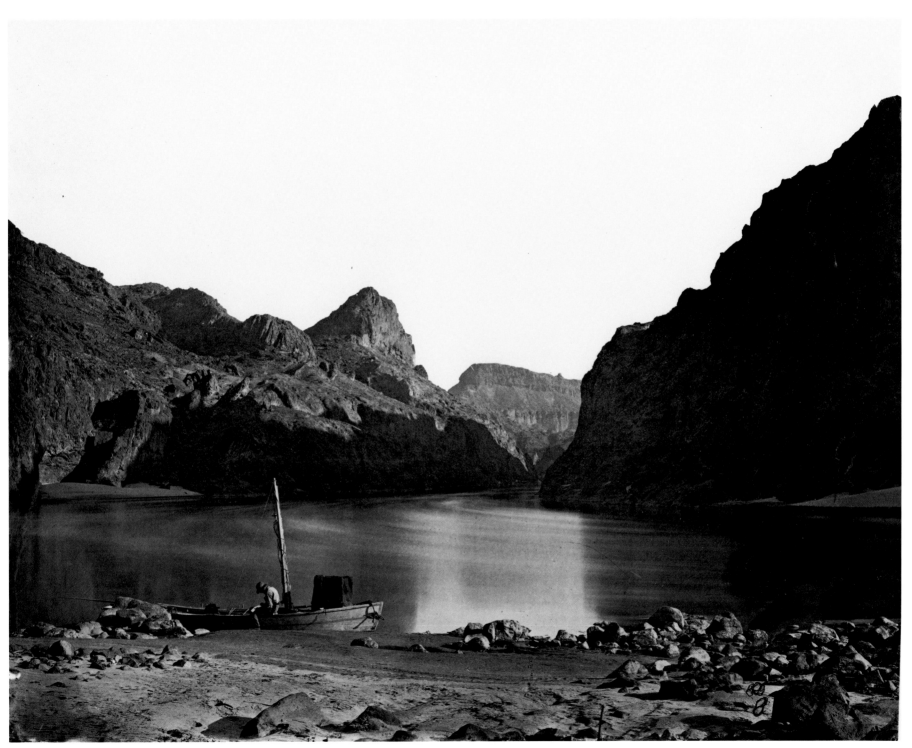

Black Canyon, looking above from Camp 8, Colorado River, Arizona, 1871

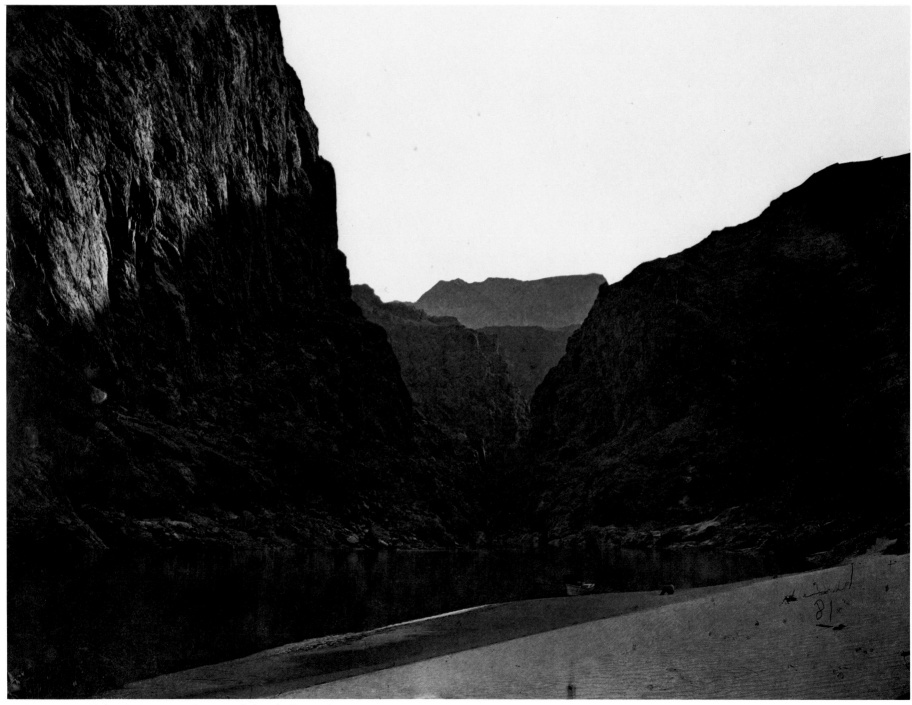

Black Canyon, looking below near Camp 8, Colorado River, Arizona, 1871

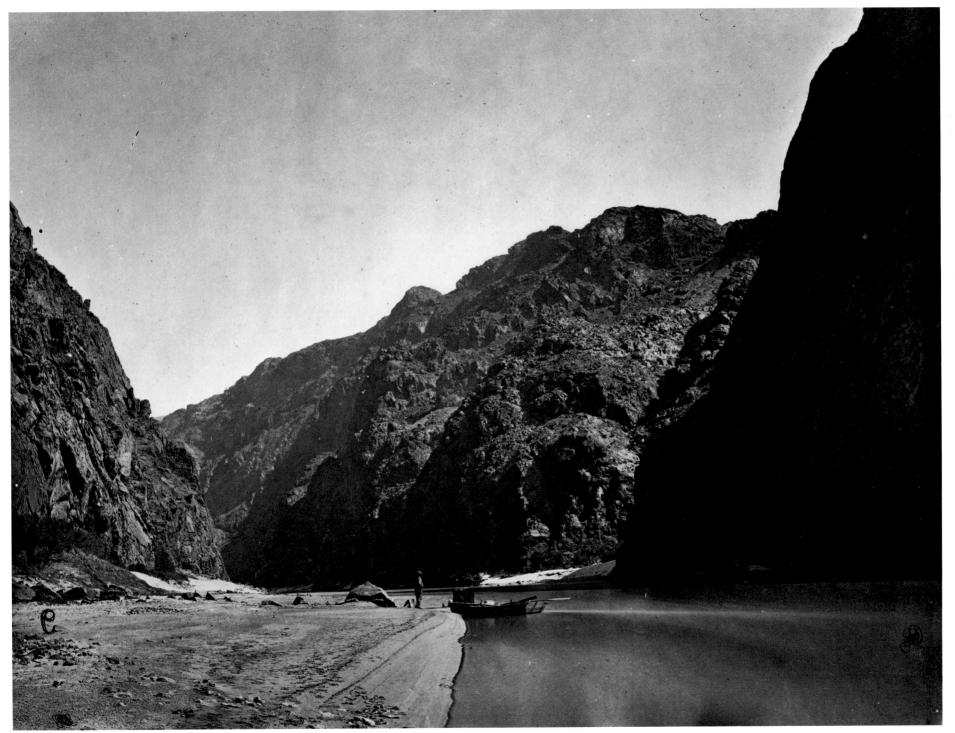

Black Canyon, looking above from Mirror Bar, Colorado River, Arizona, 1871

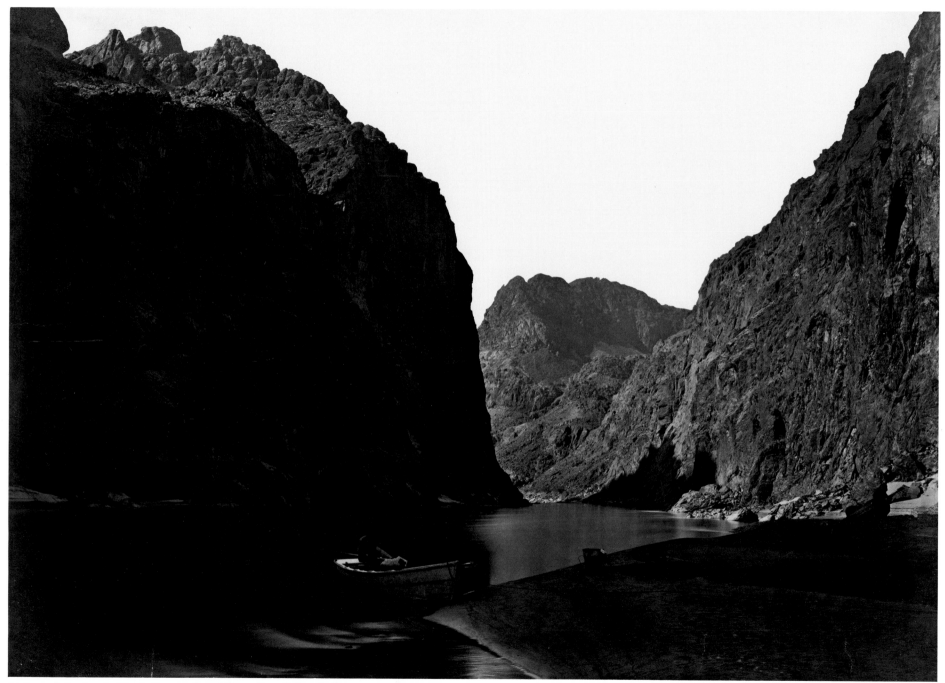

Light and shadow in Black Canyon from Mirror Bar, Colorado River, Arizona, 1871

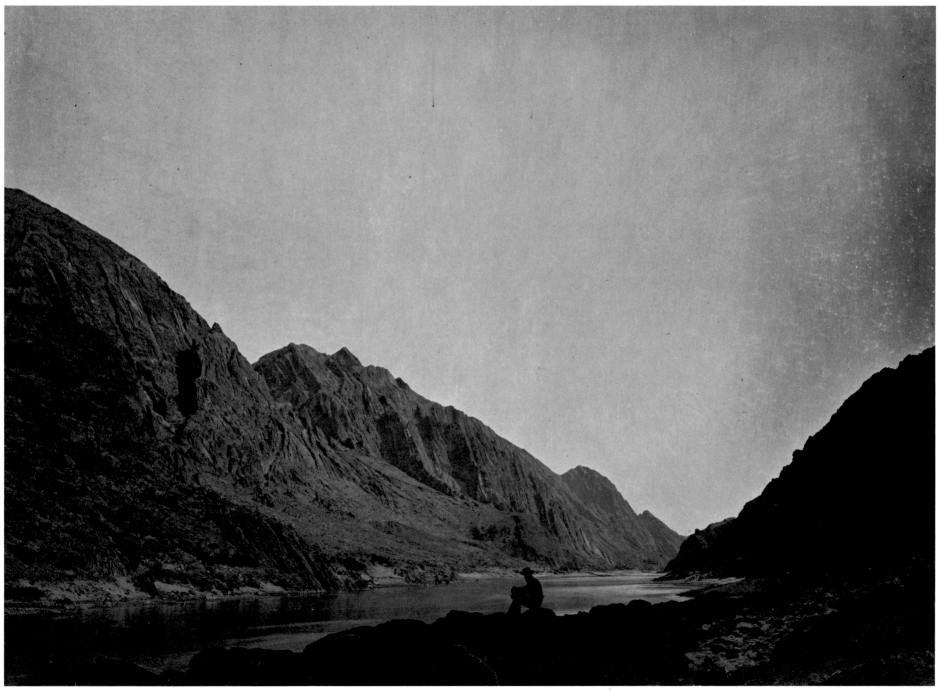

Black Canyon, looking above from Camp 8, Colorado River, Arizona, 1871

Not very far in the future it may be seen that the evolution of the environment has been the major cause of the evolution of life; that a mere Malthusian struggle was not the author and finisher of evolution; but that He who brought to bear that mysterious energy we call life upon primeval matter bestowed at the same time a power of development by change, arranging that the interaction of energy and matter which make the environment should from time to time, burst in upon the higher current of life and sweep it onward and upward to ever higher and better manifestations.

Clarence King, "Catastrophism and Evolution"

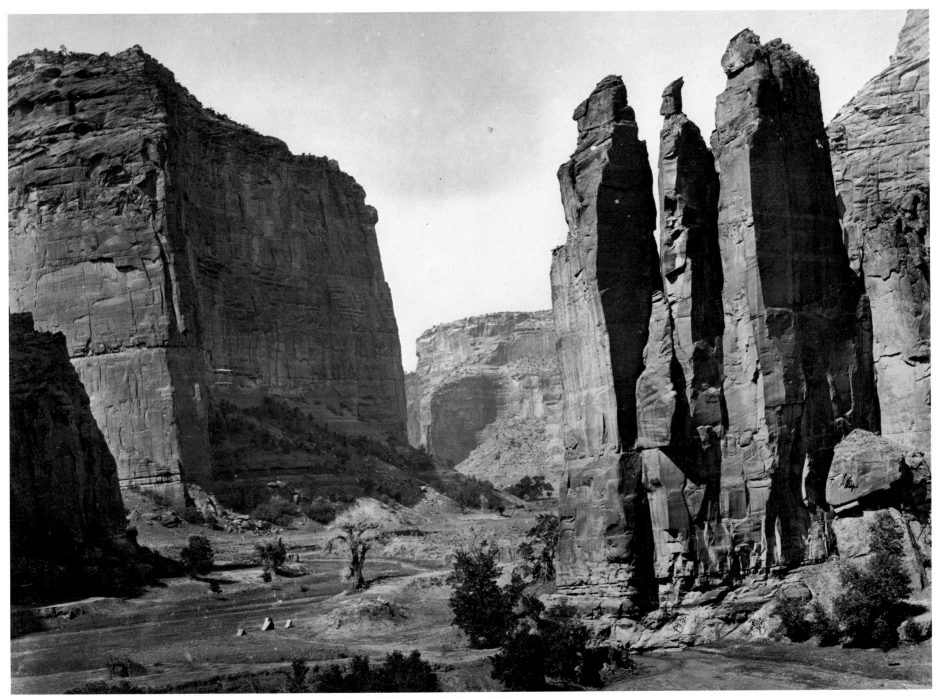

Canyon de Chelly, New Mexico, walls of the Grand Canyon about 1200 feet in height, 1873

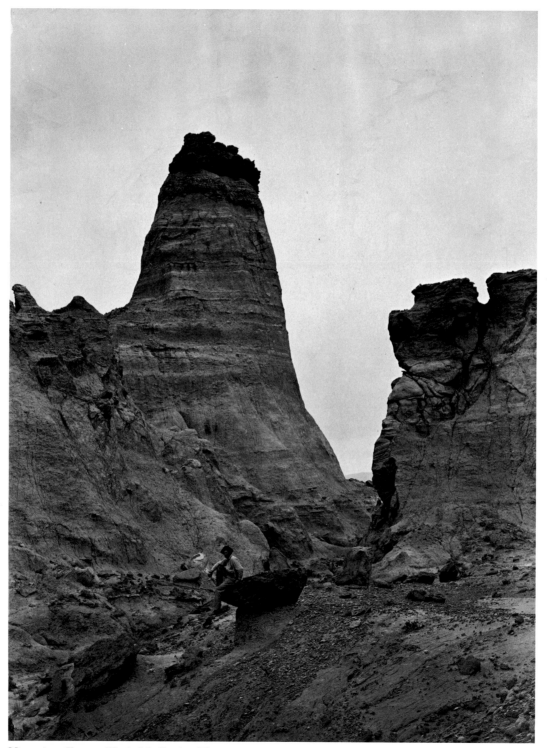

Mauvaises Terres, Washakie Basin, Wyoming, 1872

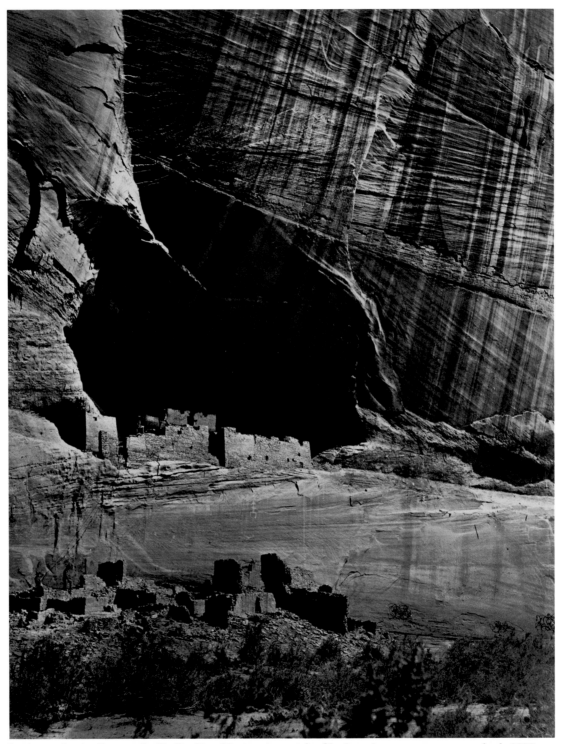

Ancient ruins in Canyon de Chelly, New Mexico, in a niche fifty feet above present canyon bed, 1873

Music Mountain, Truxton Springs, Arizona, 1871

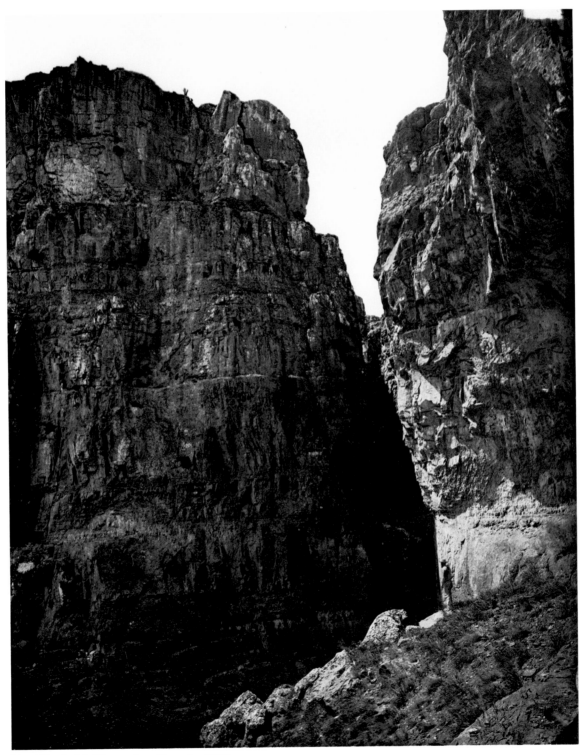

East Humboldt Mountains, Nevada, 1868

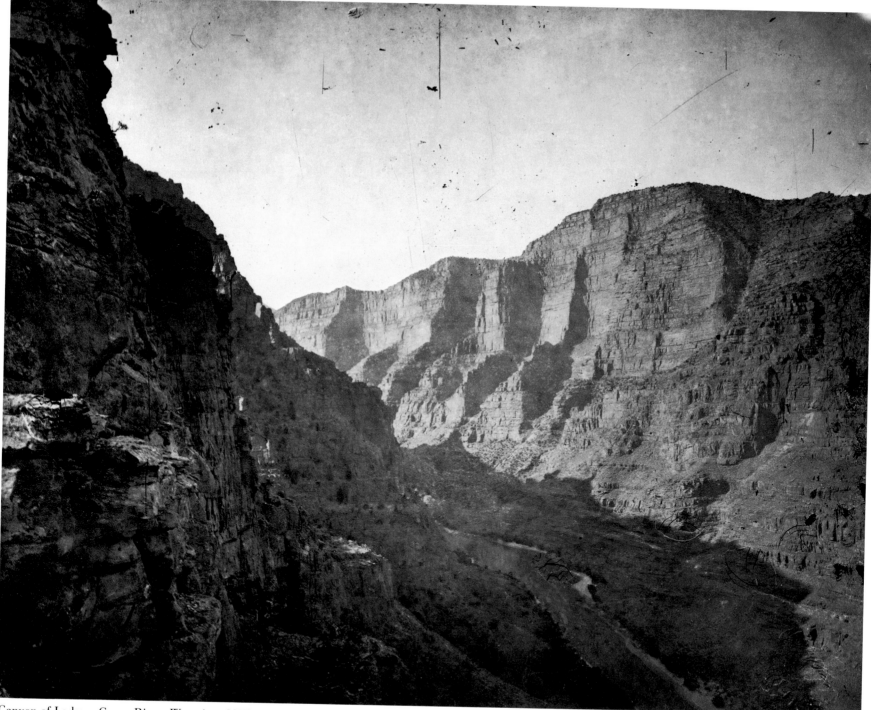

Canyon of Lodore, Green River, Wyoming, 1872

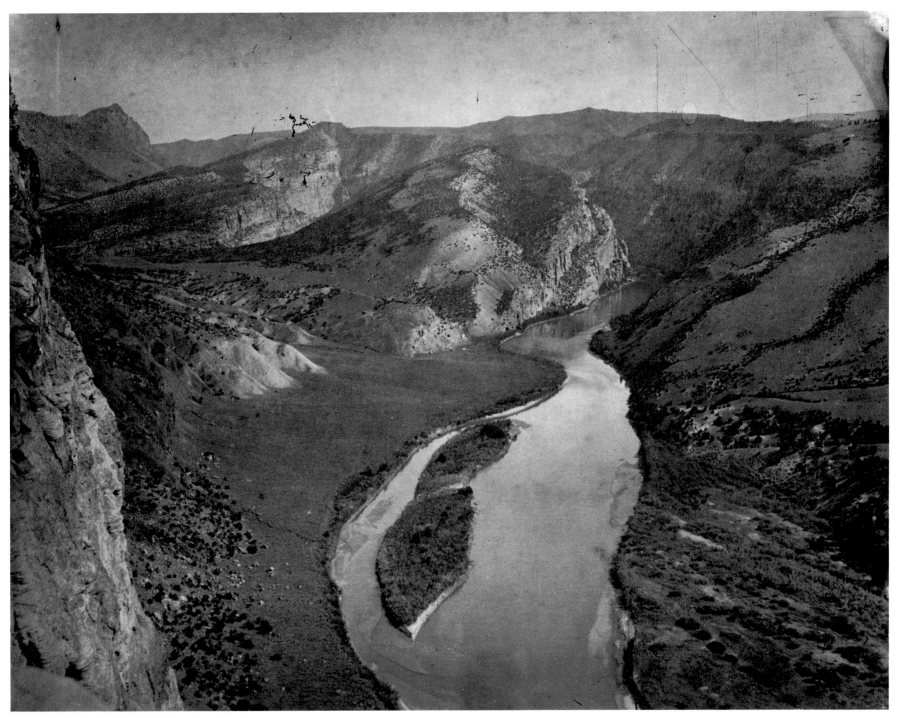

Horseshoe Canyon, Green River, Wyoming, 1872

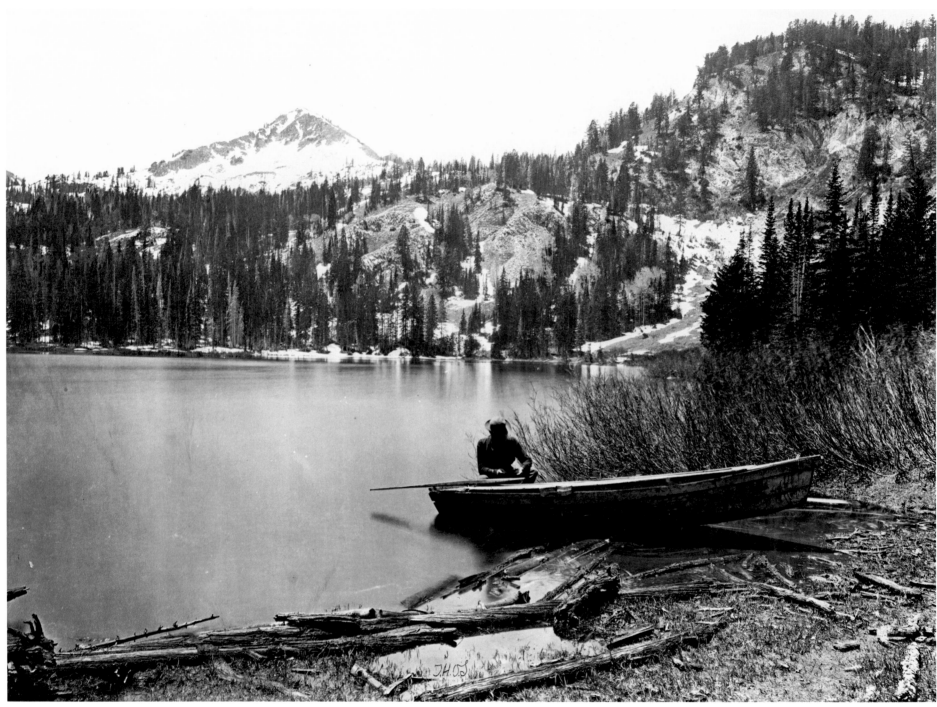

Cottonwood Lake, Wasatch Range, Utah, 1869

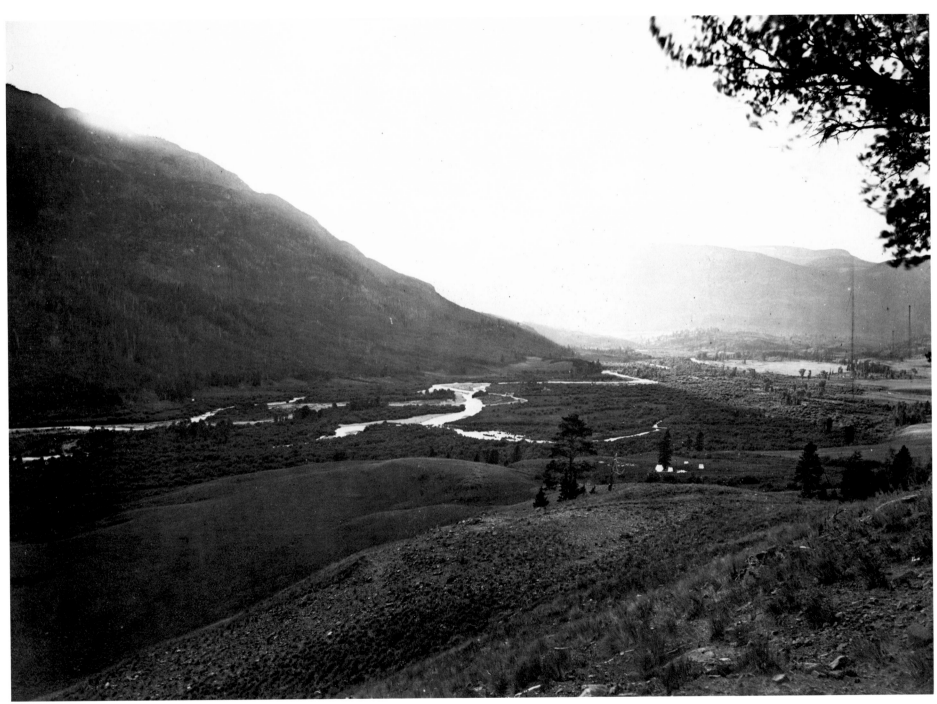

View near head of Conejos River, Colorado, 1874

Lake in extinct volcanic crater, Arizona, 1871

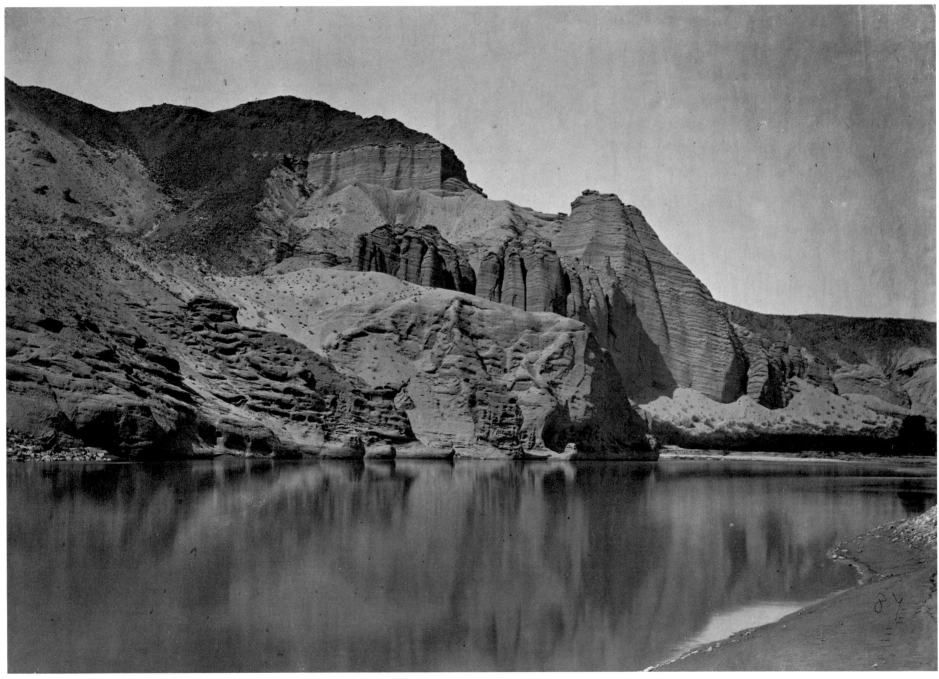

Castellated sand bluffs, Fortification Rock, Colorado River, Arizona, 1871

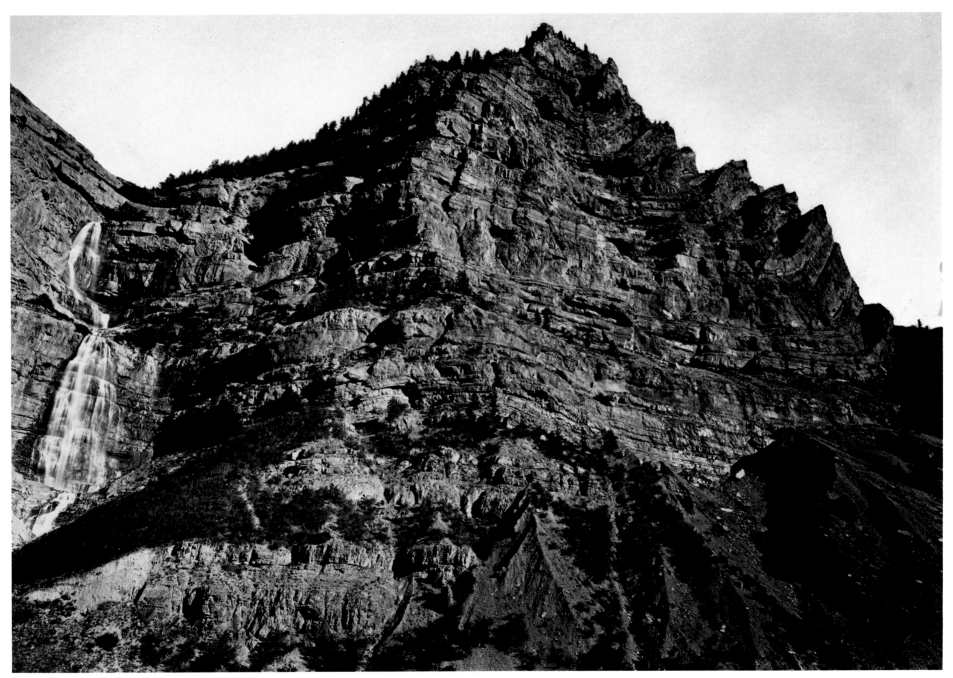

Provo Canyon Falls, Utah, 1869

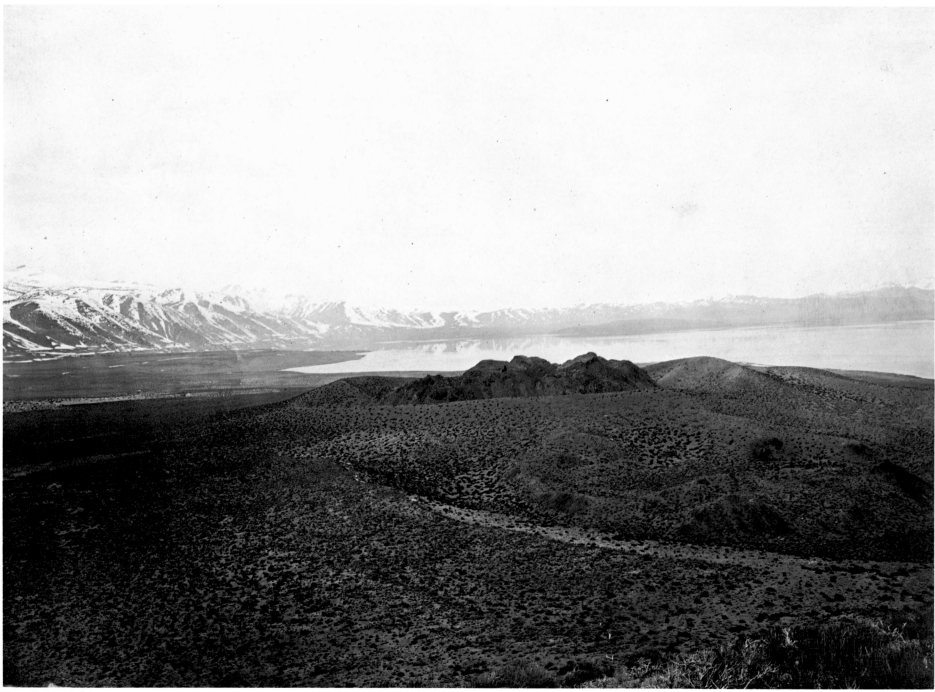

Mono Lake, California, 1868

Oak grove, Sierra Blanca Range, Arizona, 1873

One may see the old, rude scars of mining; trenches yawn, disordered heaps cumber the ground, yet they are no longer bare. Time, with friendly rain, and wind and flood, slowly, levels all, and a compassionate cover of innocent verdure weaves fresh and cool from mile to mile. While Nature thus gently heals the humble Earth, God, who is also Nature moulds and changes Man.

Clarence King, *Mountaineering in the Sierra Nevada*

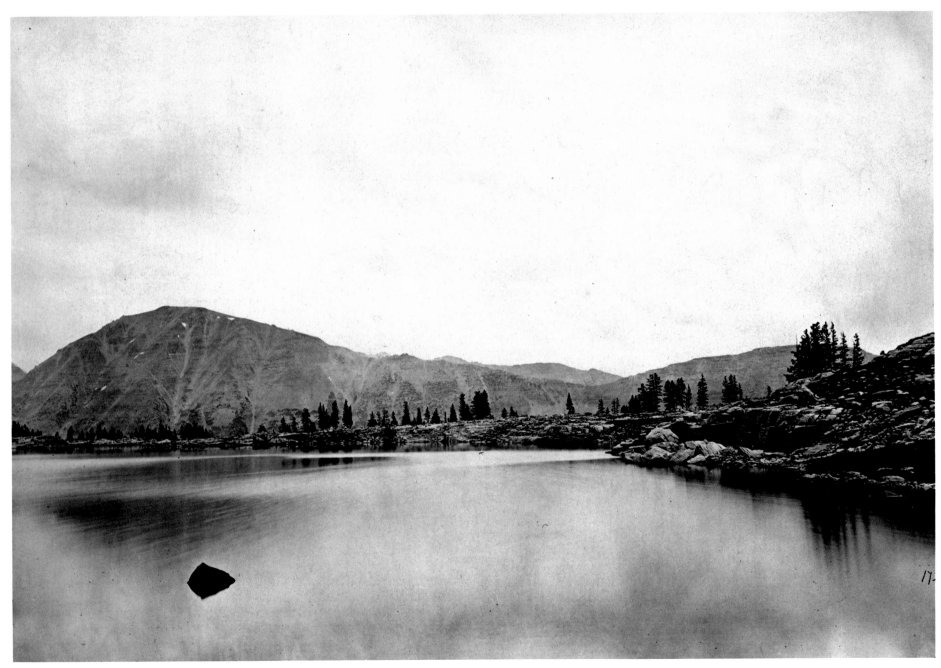

Volcanic Islands, Mono Lake, California, 1868

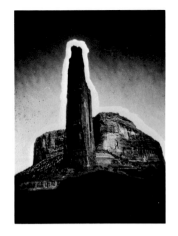

TECHNICAL NOTE

O'Sullivan made his negatives by the wet-collodion process, which, unlike modern processes, is sensitive only to blue and ultraviolet light. Although the ground in a scene to be photographed may appear to be primarily green and brown, it actually reflects blue and ultraviolet radiation, which exposes the plate. Since the sky is much richer in blue and ultraviolet than the ground, an exposure that is calculated to provide a robust image of the ground will greatly overexpose the sky. Nearly all modern writers on the wet-plate process have assumed that the uniformly white areas on prints were the result of such overexposures in wet-plate negatives, but this is not true. On a wet plate overexposed areas become less rather than more opaque with increasing exposure. Moreover, the reversal is not continuous, and in prints these overexposed areas look gray and mottled. To correct this problem landscape photographers carefully outlined the horizon of the negatives with opaque paint and cut mats to cover the sky. All of O'Sullivan's prints that have open white skies were made from negatives that were reworked by hand.

Unlike most landscape photographers of his time, O'Sullivan also devised other approaches to the problem of skies and clouds. At times he made negatives that are only slightly overexposed in the skies and correspondingly underexposed in the ground (page 75), producing skies with distinct, even tones. He also produced negatives that are underexposed in the ground, especially when he wanted sheer, dark cliffs that show little or no structural detail. Finally, by balancing the exposure of the ground to the sky, O'Sullivan was able to produce some landscapes with remarkable cloud formations (page 55). Underexposed negatives of this kind lack contrast and are particularly difficult to print on albumen paper, the standard print medium of the period. O'Sullivan's interest in achieving certain effects required that he put extra effort into the printing of these negatives.

Above: Explorer's column, Canyon de Chelly, New Mexico, 1873

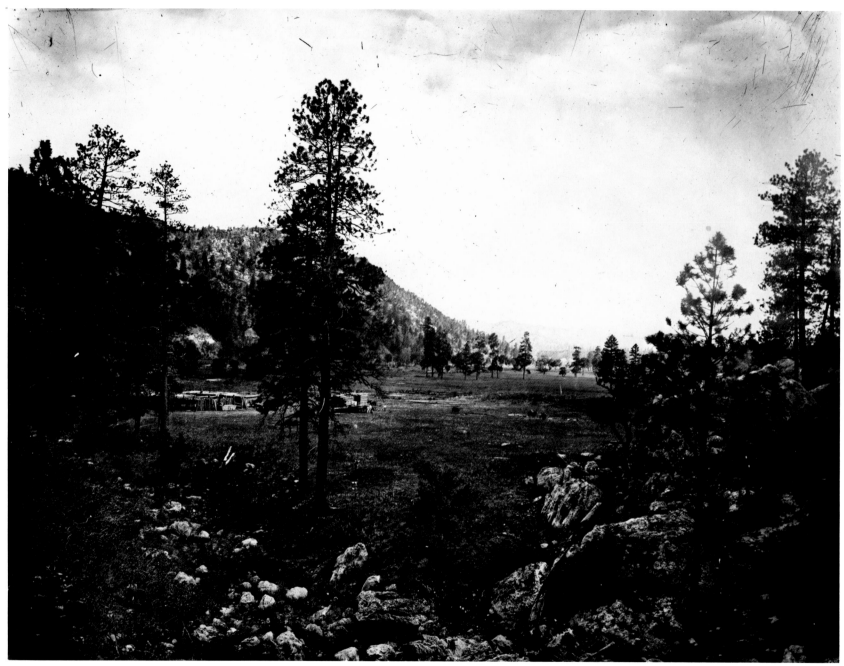

Cooley's Park, Sierra Blanca Range, Arizona, 1873

AFTERWORD

Timothy H. O'Sullivan's achievements as a photographer have been warmly appreciated by students of photographic history, but much of his western work has never been published. This book attempts to remedy that oversight.

The plates here draw solely from O'Sullivan's work as a photographer from 1867 to 1874 to two great American expeditions to the interior—the King and Wheeler surveys. Although O'Sullivan produced many photographs of the Civil War and accompanied a survey of Darien, now Panama, as expedition photographer in 1870, only his western exploration photographs form a unique and integrated whole, coherent in subject matter as well as in approach.

Many of the reproductions here were made from original prints in the collection of the National Archives in Washington, D.C., but a number were reproduced from modern albumen prints made from O'Sullivan's negatives in Washington by the Chicago Albumen Works, because no original prints existed, because the original prints were faded or otherwise unsuitable for reproduction, or because I wished to show multiple-plate views of which no originals exist. Finally, a handful of prints were made by enlarging stereo negatives and printing them on albumen paper. (O'Sullivan himself sometimes used enlargements. All of his 9-×-7-inch views made in the Virginia City, Nevada, mines, for example, were made with negatives enlarged from stereo views.) Whenever possible in the printing, I relied upon existing prints (or roughly comparable prints) as guides for the modern printing of the negatives.

Joel Snyder
The University of Chicago
June 1981

CHRONOLOGY

1840
Probably born in Ireland

About 1842
Emigrates to the United States with his parents, Jeremiah and Ann D. O'Sullivan

1855
Confirmed at Saint Peter's Roman Catholic Church in Staten Island, New York, as "Tim Sullivan"

1858
Begins working under Alexander Gardner's direction in the Washington, D.C., studio of Mathew Brady

1861
Assists J. F. Coonley, photographer from New York, photographing Federal troops in the field around Washington, D.C. July, photographs Bull Run with Mathew Brady. Photographs Federal troop actions in South Carolina and Georgia

1862-66
May, returns from the South and is hired by Gardner as Superintendent of the Field or Copy Work to the Army of the Potamac. Photographs camp life, recently freed slaves, the new technology of war, the aftermath of battles. Work printed and published by Gardner and also published by Philp and Solomons of Washington, D.C., under the general title, *Photographic Incidents of the War*. Forty-four of his photographs appear in *Gardner's*

Photographic Sketchbook of the War, published by Philp and Solomons in 1866. Probably assists Gardner in printing throughout the year

1867
Appointed photographer to the Geological Explorations of the Fortieth Parallel by Clarence King, United-States-Geologist-in-Charge. May – June, journeys with King to San Francisco by way of the Isthmus of Darien (now Panama). July – December, photographs in western Nevada in the Truckee region, Pyramid and Winnemucca Lakes, Carson and Humboldt Sinks and deserts, West Humboldt Mountains, and in the town of Oreana

1868
Winters in Carson City and Virginia City, Nevada, and photographs surface mining operations. Descends nearly 900 feet to photograph mining beneath Virginia City by means of magnesium flares. Photographs Mono Lake, California, and surrounding region. Field work begins in May and ends in September. Photographs Toyabe Range, East Humboldt Mountains, Ruby Valley and Fort Ruby, and the Snake River and Falls of the Shoshone in Idaho. Returns to Washington in October. Begins to court Laura Virginia Pywell, sister of Washington photographer William Reddish Pywell. Makes first prints from King negatives in Treasury Department facilities, aided by his friend Lewis E. Walker

1869
May, returns to Salt Lake City, Utah, and immediately begins to photograph. Works in Great Salt Lake and surrounding region, Wasatch and Uinta Mountains, Weber and Echo Canyons, and Provo Valley. When season ends in September, returns to Washington Washington

1870
11 January, named photographer to the Darien Expedition by Commander T. O. Selfridge and sails immediately from New York with Captain E. P. Lull. Photographs on the Atlantic side of the Isthmus. July, returns to Washington. Placed back on King's payroll and again prints King negatives at the Treasury Department with Lewis E. Walker. With King's approval, hired by Lieutenant George Montague Wheeler in late September to accompany him on his explorations in the Southwest beginning the following spring

1871
May, begins field work for Wheeler at Halleck Station, Nevada. Photographs in eastern California, Nevada, and Arizona. Photographs mining operations, Indians, Death Valley, and ascends the Colorado River through the Grand Canyon to Diamond Creek. When field season ends in December, returns directly to Washington

1872
15 January, reports to Wheeler in Washington and works on the printing of the season's negatives. March, at King's request, re-

turns to Fortieth Parallel payroll. April, field season begins. Photographs in southeastern Wyoming and northwestern Colorado as well as in Utah. Makes photographs of the Green River and Canyon, Yampa River and Canyon, Washakie Badlands, Flaming Gorge, Gate of Lodore. November, returns to Washington at end of season

1873

11 February, marries Laura Virginia Pywell at the E Street Baptist Church, Washington. Engaged in printing for Wheeler and King throughout the winter. May, returns to Wheeler's survey, now called United States Geographical Surveys West of the One Hundredth Meridian. Photographs in Arizona and New Mexico making views of Indian life, Canyon de Chelly, the eastern end of the Grand Canyon, and a number of army installations. October, returns to Washington and begins printing for both King and Wheeler

1874

May, temporarily takes himself off Wheeler's payroll and begins printing, under contract to the Corps of Engineers, through July, when he returns to the survey. Photographs in southern Colorado and northern New Mexico, again spending much time on Indian life. At the completion of his work, travels alone to Shoshone Falls in Idaho and makes his last western pictures there. Late November, returns to Washington. December, goes off payroll and works, again under contract, printing for the Corps of Engineers

1875

Continues printing under contract to Wheeler. 11 November, requests personal use of Wheeler negatives to make views and stereos for sale to the general public

1876

Continues contract work for Wheeler. 13 September, son stillborn, buried at Rock Creek Cemetery in Washington. Boards at 318 Indiana Avenue

1877

Works in Washington and lives in the Pywell home at 625 D Street, N.W.

1878

Lives in Pywell home and works with William J. Armstrong. Listed in *Washington Directory* as Armstrong & Co. (William J. Armstrong and Timothy H. O'Sullivan, photographers), 818 F Street, N.W.

1879

Lives at 332 First Street, N.E.

1880

Lives at 803 New Jersey Avenue, N.W., and works for newly formed United States Geological Surveys (under the direction of Clarence King) as a temporary employee. His friend Lewis E. Walker dies, and he applies for Walker's job at the Treasury. 6 November, appointed to post

1881

March, onset of tuberculosis of the lungs forces him to quit Treasury Department. Returns to parents' home on Staten Island, New York, to convalesce. 18 October, Laura Virginia Pywell O'Sullivan dies. Returns to Washington for funeral at Rock Creek Cemetery. Returns for the last time to Staten Island. 22 December, placed under the care of a physician for the treatment of tuberculosis

1882

14 January, dies at age forty-one or forty-two. Cause of death listed as "Phthisis Pulmona Cis" (pulmonary tuberculosis). Death certificate identifies him as "Timothy H. Sullivan" and lists his occupation as "photographer." 17 January, buried at Saint Peter's Cemetery, Staten Island. Church cemetery records list him as "Tim Sullivan"

SELECTED BIBLIOGRAPHY
PRIMARY SOURCES

Hayden, Ferdinand Vandiveer. *Annual Reports of the United States Geological and Geographical Surveys of the Territories*. Washington, D.C.: U. S. Government Printing Office, 1868–83.

Jackson, William Henry. *Time Exposure*. New York: G. P. Putnam's Sons, 1940.

King, Clarence. "The Age of the Earth." *American Journal of Science* 45 (January 1893): 1–20.

————. *Annual Reports of the United States Geological Explorations of the Fortieth Parallel*. Washington, D.C.: U. S. Government Printing Office, 1871–78.

————. "The Ascent of Mount Tyndall." *Atlantic Monthly* 28 (July 1871): 64–76.

————. "Catastrophism and Evolution." *The American Naturalist* 11, no. 8 (August 1877), 449–70.

————. "The Falls of the Shoshone." *Overland Monthly* 5, no. 4 (October 1870): 379–85.

————. *Mountaineering in the Sierra Nevada*. Edited with a preface by Francis P. Farquhar. New York, 1946.

————. "Note on the Uinta and Wahsatch Ranges." *American Journal of Science,* 3d ser. 11 (1876): 157–67.

————. editor, Professional Papers of the Engineer Department U. S. Army, 18. 7 vols. & atlas. Washington, D.C.: U. S. Government Printing Office, 1877–78. The following volumes are especially important:

 I. King, Clarence. *Systematic Geology.* 1878.

 II. Hague, Arnold, and Emmons, Samuel Franklin, *Descriptive Geology.* 1877.

 III. Hague, James D., and King, Clarence, *Mining Industry.* 1877.

 IV. Meek, Fielding Bradford. Pt. I: *Palaeontology.* 1878. Hall, James, and Whitfield, R. P. Pt. II: *Palaeontology.* 1878. Ridgway, Robert. *Ornithology.* 1878. Includes an important diary of the day-to-day survey activities, 1867–69 seasons.

————. *The Three Lakes: Marian, Lall, Jan, and How They Were Named*. Christmas, 1870. Repr. with an introduction by Francis P. Farquhar, *Sierra Club Bulletin* 24, no. 3 (1939). Original copy in New York Public Library.

Wheeler, Captain George Montague. *Report Upon United States Geographical Surveys West of the One Hundredth Meridian*. 7 vols. Washington, D.C.: U. S. Government Printing Office, 1875–89.

In addition to these sources, the National Archives and Record Service contains important documents relating to the surveys with which O'Sullivan served. For King, see Record Group 57; for Wheeler, see Record Group 77. For King, other important sources of manuscripts may be found at the Huntington Library, San Marino, California, and at the American Museum of Natural History, New York, New York.

SECONDARY SOURCES

Adams, Henry. *The Education of Henry Adams*. New York: Charles Scribner's Sons, 1931.

Bartlett, Richard A. *Great Surveys of the American West*. Norman: University of Oklahoma Press, 1980.

Baumhofer, Hermione. "T. H. O'Sullivan," *Image* 2 (April 1953): 21.

Cobb, Josephine. "Alexander Gardner." *Image* 7 (June 1958): 124–36.

Darrah, William Culp. *Powell of Colorado*. Princeton: Princeton University Press, 1951.

Gilbert, Grove Karl. *John Wesley Powell*. Chicago, 1903.

Goetzmann, William H. *Army Exploration in the American West*. New Haven: Yale University Press, 1960.

————. *Exploration and Empire*. New York: Alfred A. Knopf, 1966.

Hague, James D.; Carey, Edward; and La-Farge, John, eds. *Clarence King Memoirs*. New York, 1904.

Horan, James D. *Timothy O'Sullivan: America's Forgotten Photographer*. New York: Bonanza Books, 1966.

Irving, Washington. *Astoria*. New York, 1904.

Naef, Weston, and Wood, James. *Era of Exploration: The Rise of Landscape Photography in the American West, 1860–1885*. New York: The Metropolitan Museum of Art, 1975.

Newhall, Nancy, and Newhall, Beaumont. *T. H. O'Sullivan: Photographer*. Rochester: The George Eastman House, 1966.

Snyder, Joel. "Photographers and Photographs of the Civil War." In *The Documentary Photograph as a Work of Art*, Chicago: The David and Alfred Smart Gallery/University of Chicago, 1976.

————. "Picturing Vision." *Critical Inquiry* 6, no. 3: 499–526.

Snyder, Joel, and Allen, Neil. "Photography, Vision and Representation." *Critical Inquiry* 2, no. 1: 143–69.

Taft, Robert. *Photography and the American Scene*. New York: Macmillan, 1938.

O'SULLIVAN ALBUMEN PRINTS IN OFFICIAL PUBLICATIONS

COMPILED BY JONATHAN HELLER

When the results of the surveys were circulated—and later made public—they were often accompanied by supporting photographs, issued in limited sets. The following is a listing of the photographs by Timothy O'Sullivan that were officially published by the King and Wheeler surveys.

CLARENCE KING SURVEYS, 1867–1869, 1872

Photographs: Geological Explorations of the 40th Parallel, Clarence King, Geologist in Charge

1867–68 (pub. 1868–69).
 Set 1: 80 landscapes, edition of less than 10
 Set 2: 50 landscapes, edition of less than 10
1867–69 (?) (pub. 1870): unknown no. landscapes, edition of 4
1867–72 (pub. 1873): unknown no. landscapes in 3 portfolios, edition of 1; B, unknown no. stereo cards in 1 box, edition of 1

Photographs Taken in Connection with the Geological Exploration of the Engineer Department, U.S. Army, Clarence King, Geologist in Charge 1867–1872 (pub. 1876)

 Set 1: 180 landscapes, edition of 6 (inc. 1 for Library of Congress, 1 for the Centennial Exposition)
 Set 2: unknown no. stereo cards, edition of 1

Miscellaneous prints and stereo cards were made from King Survey negatives through 1880, but none were issued in official publications. Stereo cards appear both on official mounts and blank mounts.

GEORGE MONTAGUE WHEELER SURVEYS 1871–74

Photographs Showing Landscapes, Geological and other Features, of Portions of the Western Territory of the United States, Obtained in Connection with Geographical and Geological Explorations and Surveys West of the 100th Meridian, 1st Lieut. Geo. M. Wheeler, Corps of Engineers, U.S. Army, In Charge

1871–72 (pub. 1873): 50 landscapes, edition of less than 4
1871–73 (pub. 1874–75)
 Set 1: 50 landscapes, edition of 50
 Set 2: 25 landscapes (half set), edition of 300
 Set 3: 100 stereo cards, edition of 50
 Set 4: 50 stereo cards (half set), edition of 300
1871–74 (pub. 1875–76)
 Set 1: 25 landscapes, edition of 200
 Set 2: 50 stereo cards, edition of 1,000
1871–72 Specially printed for the Vienna Exposition (pub. 1876): 109 landscapes, edition of 1
1871–74 Specially printed for the Centennial Exposition (pub. 1876):
 Set 1: at least 100 landscapes, edition of 1 (?)
 Set 2: at least 100 stereo cards, edition of 1 (?)

PHOTOGRAPH SOURCES

Aperture and the Philadelphia Museum of Art would like to thank the lenders to the exhibition and the publication *American Frontiers: Photographs of Timothy H. O'Sullivan, 1867–1874*. The works illustrated are in the collection of the National Archives, Washington, D.C., except as follows: Chicago Albumen Works (prints from original negatives in the National Archives, Washington, D.C.), pages 2, 23 *below right*, 24, 30–31, 36, 44, 46, 47, 48, 53, 55, 56, 57, 60–61, 71, 75, 77, 87, 88, 89, 97, 98, 99, 102–3, 107, 119; Charles Isaacs collection, pages 74, 91; Thomas V. Lange collection, page 40 *above*; The Metropolitan Museum of Art, New York, page 41; National Museum of American Art, The Smithsonian Institution, Washington, D.C., page 39 *below*; New York Public Library, page 18; E. Marshall Pywell collection, pages 14, 32; The Rockwell-Corning Museum, Corning, New York, page 39 *above*; Department of Special Collections, Research Library, University of California at Los Angeles, page 40 *below*; Samuel Wagstaff, Jr., pages 15, 26, 43, 50, 101. The Miller-Plummer Collection of Photography and the American Philosophical Society have lent works to the exhibition that do not appear in the publication.

ACKNOWLEDGMENTS

The research involved in bringing this book together required the assistance of many people. I am indebted to E. Marshall Pywell of Washington, D.C., who allowed me to invade his privacy and shared important information about his great-grand-uncles Timothy H. O'Sullivan and William Reddish Pywell, as well as previously unpublished family photographs. Rick Dingus allowed me to serve as an unofficial reader of his master's thesis for the Department of Art, University of New Mexico—a perceptive and sensitive study of O'Sullivan's work.

I am grateful to the administration of the National Archives for the great privilege of working directly with O'Sullivan's negatives and original prints. Invaluable assistance was given to me by: James W. Moore, Director of the Audio-Visual Archives Division; Richard F. Myers, Deputy Director of that division; Joe Thomas, Chief of the Still Pictures Branch; and Barbara Burger, reference researcher. Owing in great part to the cooperation and graciousness of Dr. Caryl Marsh, Curator of Exhibitions and Research, it was possible to print O'Sullivan's negatives at the Archives and to borrow a large number of original prints for reproduction in this book and for exhibition at the Philadelphia Museum of Art. William Leary, Archivist, was an ever enthusiastic supporter of this project, without whose masterful assistance it would never have come into being.

Jonathan Heller of the Still Pictures Branch at the National Archives shared much of his important research on O'Sullivan with me. His cataloguing of O'Sullivan's photographs by year and location was crucial to my work and is indispensable to any future O'Sullivan scholarship.

Doug Munson and Gordon Wagner of the Chicago Albumen Works printed O'Sullivan's negatives by the light of the sun on the roof of the National Archives within a city block of the studios used by O'Sullivan for the same purpose. Doug Munson enlarged O'Sullivan's stereographic negatives with such precision that the duplicates match the originals in all respects except size. I am extremely grateful to Munson and Wagner for their exceptional work.

Finally, I wish to acknowledge a special obligation to Beaumont Newhall for his long-term support and enthusiasm. J.S.

Altar, Church of San Miguel, Santa Fe, New Mexico, 1873

Hark ye yet again — the little lower layer. All visible objects, man, are but pasteboard masks. But in each event — in the living act, the undoubted deed — there, some unknown but still reasoning thing put forth the mouldings of its features from behind the unreasoning mask. If man will strike, strike through the mask. How can the prisoner reach outside except by thrusting through the wall? *Herman Melville,* Moby Dick